CW01266910

BFI TV Classics

BFI TV Classics is a series of books celebrating key individual television programmes and series. Television scholars, critics and novelists provide critical readings underpinned with careful research, alongside a personal response to the programme and a case for its 'classic' status.

The
World
at War

Taylor
Downing

A BFI book published by Palgrave Macmillan

Images from *The World at War*, © FreemantleMedia

Whilst considerable effort has been made to correctly identify the copyright holders, this has not been possible in all cases. We apologise for any omissions or mistakes in the credits and we will endeavour to remedy, in future editions, errors brought to our attention by the relevant rights holder.

None of the content of this publication is intended to imply that it is endorsed by the programme's broadcaster or production companies involved.

First published in 2012 by
PALGRAVE MACMILLAN

on behalf of the

BRITISH FILM INSTITUTE
21 Stephen Street, London W1T 1LN
www.bfi.org.uk

There's more to discover about film and television through the BFI. Our world-renowned archive, cinemas, festivals, films, publications and learning resources are here to inspire you.

Palgrave Macmillan in the UK is an imprint of Macmillan Publishers Limited, registered in England, company number 785998, of Houndmills, Basingstoke, Hampshire RG21 6XS. Palgrave Macmillan in the US is a division of St Martin's Press LLC, 175 Fifth Avenue, New York, NY 10010. Palgrave Macmillan is the global academic imprint of the above companies and has companies and representatives throughout the world. Palgrave® and Macmillan® are registered trademarks in the United States, the United Kingdom, Europe and other countries.

Set by Cambrian Typesetters, Camberley, Surrey
Printed in China

This book is printed on paper suitable for recycling and made from fully managed and sustained forest sources. Logging, pulping and manufacturing processes are expected to conform to the environmental regulations of the country of origin.

British Library Cataloguing-in-Publication Data
A catalogue record for this book is available from the British Library
A catalog record for this book is available from the Library of Congress
10 9 8 7 6 5 4 3 2 1
21 20 19 18 17 16 15 14 13 12

ISBN 978-1-84457-483-4

Contents

Preface

The World at War is unique in factual television. Forty years after its first transmission it is as popular, possibly even more popular, than it was when first shown. Factual channels that were not in existence when the series was made eagerly compete to show it today. This is as true in the US and in many other major television markets, as it is in the UK. No other factual series can claim this. On a personal level, the series has exerted an immense influence over my career. I joined Thames Television as a researcher in the Documentary Department to work on history programmes about five years after the series was first shown. Many of the key people from the series were still there and those of us who had not worked on it regarded the series in awe. Then, years later, when I was producing my own history documentaries through Flashback Television for Channel 4 and later for American television, *The World at War* again cast its shadow. Although I was now more critical of the series, it still represented a pinnacle of film-making we all tried to aspire to, even if we wanted to move on from its format of intercutting talking heads with archive film. Later still, in the mid-90s, I had the opportunity to work with Jeremy Isaacs, Martin Smith and some others from *The World at War* on the series made for Ted Turner, *Cold War*. Turner once told me he had watched *The World at War* three times ('78 hours of my life watching that series' as he put it) and he wanted *Cold War* to be made to its template.

So, it has been a real joy to research the making of this series and to look again critically at how the programmes work. It has been a

pleasure to meet and interview many of the key members of the original production team, some of whom I have known for years, others of whom I have met for the first time. I have credited all these interviews in the Notes. I hope I have not been overexaggerated in my praise, for I do believe that praise is due overall despite certain aspects that may not come across well today. The series was made with an ambition that it is impossible to find in television production today. And it was made in an era when programme makers rather than accountants and marketing people ruled the roost in television companies.

The Imperial War Museum has a superb archive of paper documents relating to the making of the series and access to these records has been invaluable. First, there are the personal papers of Noble Frankland, Director of the IWM at the time but also principal adviser to Jeremy Isaacs on the series. I thank Dr Frankland for access to his papers and for permission to quote from them. Second, there are the central archives of the museum that hold all the records chronicling the fascinating negotiations that went on during the setting up of the series which resulted in one of the most remarkable deals ever done in television production (see Chapter 6). Third, there are the production records held by the film archive of the IWM. The team at Thames deposited all their production files with the IWM after completing the series and access to these records enables the student of television production to follow in dramatic and gripping detail the daily ins and outs, the ups and downs of making the series. I am grateful to IWM staff for giving me access to these files, including Sarah Henning, the museum archivist, and Jane Fish and Paul Sargent of the film archive. Today, these records more than make up for the sad lack of any existing Thames Television archive with its own production documentation. Finally, many of those whom I interviewed for the writing of the book were generous not only in their time but also in loaning me their own personal files and papers from the making of the series. Again, all these are credited in the Notes. All this adds up to a rich treasure trove of material.

I have been privileged to meet and spend time with the makers of the series. This book is dedicated to them and especially to the memory of those who have died over recent years, particularly Phillip Whitehead, Sue McConachy and Isobel Hinshelwood.

Taylor Downing, May 2012

1 The Time

The World at War began transmitting in the UK on 31 October 1973. It continued its run on Wednesday evenings on the ITV network in the primetime slot of 9.00pm for twenty-six weeks, with a short break over Christmas, until 8 May 1974. Britain in the early 1970s was a different country. Hair was long, skirts were still short, wages were rising and jobs were abundant. People looked forward to holidays in Spain and houses were full of consumer objects. There were new motorways, the first pedestrian shopping centres and Victorian factories had been replaced by glass and concrete office blocks. Everywhere, Britain seemed to be modernising. People were getting used to new telephone numbers and new decimal coins. Many in the middle classes drank instant coffee rather than tea, and sweet white wine rather than draft beer. Other things, however, had not changed much. The *Daily Mirror* was still the top-selling newspaper, read by an estimated 15 million working people each day. *The Times* was still the newspaper read by about 1.3 million of the 'top people'. But Rupert Murdoch had recently bought the *Sun* and the introduction of Page Three girls in the early 70s along with its relentless pursuit of celebrities helped it rise to become the best-selling paper in the country later in the decade. While Britain formally joined the European Economic Community in 1973, the results of Commonwealth immigration meant that the country's cities were already showing hints of multiculturalism. Going out for a curry was beginning to rival a fish-and-chip supper. But after decades of growing affluence, the nation was suddenly hit by a tsunami of high inflation,

deep recession, miners' strikes and national emergencies in the winter of 1973–4.

During the war in the Middle East in October 1973 the Americans put the global US military establishment on a nuclear alert known as DefCon 3, for the first time since the Cuban Missile Crisis. The war, eventually won by Israel, resulted in a 70 per cent hike in oil prices by the Arab OPEC states, intended to impact on the West. For the first time in the twentieth century oil became scarce. Not only were there long queues at petrol stations, but the foundations of the economic growth that had continued unabated since World War II seemed to be threatened. In Britain, when the miners started an overtime ban in November, Prime Minister Edward Heath called for a massive cutback in the use of electricity and in lighting for public buildings and neon displays. All television channels were required to close down at 10.30pm. A mammoth trade deficit seemed to push the economy over the edge. Amid signs of economic decline, the banks increased the mortgage interest rate to 18 per cent. With inflation still running at 25 per cent, the country fell into a major recession.

Other crises also filled the headlines of the winter of 1973–4. The Troubles in Northern Ireland brought IRA bomb attacks to the streets of mainland Britain. The nation looked on in horror at the growth of football hooliganism. Skinheads started to appear and urban violence seemed to be growing. In early 1974, in the face of the economic crisis, Edward Heath began to close the country down and severely limited the supply of electricity to all commercial users. Before long Britain was working for only three days a week. The energy crisis, the confrontation with the miners and the resulting chaos led to two general elections during 1974. The first, at the end of February, resulted in a hung Parliament. But when Conservative–Liberal coalition talks broke down, the Labour leader, Harold Wilson, formed a minority government. In the second election, in October, Labour won with a tiny majority of three seats. The whole period has been described by one recent historian as having 'a pervasive sense of crisis and discontent with few parallels in our modern history'.[1]

Against this backdrop of doom and gloom, collapse and catastrophe, the British people carried on with what they most liked doing. And watching television was at the top of the list. By 1973 nearly 18 million households possessed a television, and roughly one in three were colour sets. More than 90 per cent of all families had a television, far higher than the percentage that owned a washing machine or a refrigerator. This was not only a sign of the growing affluence that Britain had enjoyed for two decades but an indication of an entirely new culture that had been created in the nation's homes. An extensive 1970 survey of social habits found that by far the most popular leisure activity of Britons was watching television (97 per cent), followed by gardening (64 per cent), playing with children (62 per cent), listening to music (57 per cent), home decoration or repairs (52 per cent) and, remarkably, cleaning the car (48 per cent). Reading was at 46 per cent and going to the cinema was way down the list at 13 per cent.[2] Collective activities that had been the common pursuits of the first half of the twentieth century like going to church, or to the cinema or visiting the pub had been replaced by the home-centred activity of watching telly.

There were three television channels, BBC1, BBC2 and ITV and major events could attract vast television audiences. Soon after *The World at War* began its run, 28 million viewers gathered to watch Princess Anne's wedding to Captain Mark Phillips on 14 November 1973 at Westminster Abbey. The event typified the royal pageant that has become more familiar in recent years, with crowds lining the streets of the Mall, the red and gold of the household cavalry, the carriages and the glitter. But it was the first big royal occasion in over a decade and the first to be seen live by millions on colour television.[3] Even more had watched the FA Cup replay between Chelsea and Leeds in 1970. Television programmes were discussed everywhere, from the playground to the office, and from the pub to the factory floor. Jokes from television comedies were acted out by schoolboys, and storylines from television soaps and dramas shaped national debate about matters that were important to people. Television culture was a dominant force and the BBC and ITV 'defined and disseminated national experience in the

3

1970s'.[4] Britain in the early 70s was not just a country of IRA bombs, miners' strikes and economic crisis, it was also a nation obsessed with *On the Buses* (1969–73), *The Morecambe and Wise Show* (1968–77), *Coronation Street* (1956–) and *Match of the Day* (1964–).

It was in this context and in the climate of national decline and self-doubt that the nation escaped on Wednesday evenings for twenty-six weeks to World War II in the most ambitious factual series ever produced by ITV, *The World at War*.

2 History on Television

By the early 1970s, the history documentary was a well-established genre within the world of factual television. And within the genre of Television History there were many different styles and formats. From the early days of film-making, the art of the 'compilation film' had developed – the making of a new film by compiling shots and clips from earlier films, rather than by shooting new images. Often these films had a propaganda purpose, like the great compilation documentaries produced by the Soviet film-maker Esther Schub to celebrate the tenth anniversary of the Russian Revolution in the late 1920s, *The Fall of the Romanov Dynasty* (1927) and *The Great Road* (1928). In Britain film-makers used the compilation film format to express a pacific viewpoint in films like *Forgotten Men* (1934) with the historian Sir John Hammerton, and *The First World War* (1934) produced by the American anti-war author Laurence Stallings. During World War II there were countless examples of clips of 'historical' images being used to justify the fighting campaigns, the best known being Frank Capra's *Why We Fight* series of six films made for the US War Department in 1942 and 1943. It was intended that every member of the American armed services should see these films before heading overseas in order to understand fully why the United States was at war and what it was fighting for.[5]

After the war, as television began to take off as a cultural force in both the US and in Europe, the compilation form transferred naturally from the big to the small screen. In 1946, the first full year of

the revived post-war BBC Television Service, at least four historical film documentaries were produced.[6] Ironically, military humiliations during the Korean War (1950–3) were what prompted one of the most celebrated of these major television series. When the 'volunteers' of the Chinese People's Army overran the American-led UN troops and pushed them back from the Chinese border to positions roughly along the 38th Parallel, there was a deep sense of failure within the American military. Elite US Marine forces were routed by the Chinese troops and forced into a humbling retreat. It was in the face of these humiliations that NBC, one of the major US television networks, decided it had to remind American viewers of the greatness of the US military and produced an ambitious, twenty-six-part series of half-hour films called *Victory at Sea*. Henry Saloman, an ex-US naval officer, produced and wrote the series. The music was composed partly by Richard Rodgers (of Rodgers and Hammerstein), adding prestige to the project. Leonard Graves read the commentary. The series told the story of American military success in World War II with an emphasis on naval battles. It used only news and record film from the war and combined a rather melodramatic commentary with Rodgers's musical themes played by the NBC Symphony Orchestra. The series was shown on the BBC from October 1952 and marked the birth of ambitious, popular, multi-episode Television History.

Television was still a young medium when *Victory at Sea* became a huge hit, winning an Emmy and a Peabody Award. Furthermore it sold to forty countries around the world. United Artists edited it down into a cinema documentary and this was shown into the 1960s. It set the mould for the big, epic, expensive-to-make Television Histories that, as NBC said in its marketing, 'bring history alive in the living room'. *Harper's Magazine*, without any sense of film history, said the series 'created a new art form'. Indeed it did spawn a television genre, the TV compilation, and there were many follow-ups in the US, some of which came to the BBC, for instance *Air Power* (1956–8) and *Winston Churchill: The Valiant Years* (1960–3).[7] The latter, a twenty-six-part Anglo-American series broadcast in 1960 again relied on

archive film dramatically edited around a set of themes. Richard Burton read extracts from Churchill's speeches and from his memoir-history of World War II. Burton later said that making these programmes reminded him why he hated Churchill. But while the BBC bought some of these series, their cost and scale put British television off getting in on the act. There were occasional one-offs. Peter Morley and Cyril Bennett made *Tyranny – The Years of Adolf Hitler* for Associated-Rediffusion in 1959. At Granada, a young producer called Jeremy Isaacs delivered *The Troubles* in 1962, based on newsreels about events in Ireland from 1912 to the 1920s. He also briefly worked on Granada's *All Our Yesterdays* (1960–89), a weekly show in which Brian Inglis looked back on events of twenty-five years ago through Movietone newsreels. The series ran for more than a decade.

However, another completely different format also advanced the presentation of Television History during the 1950s and early 60s, the authored or presenter-led programme. With early television's deferential attitude towards 'great thinkers' it was perhaps not surprising that the first 'stars' of this format should be an eccentric Oxford don and a patrician art historian who was very much part of the Establishment. What were known as 'Talks' had been a regular part of BBC radio output since its early days. It was not a big jump when television came along to turn these into what were basically 'Illustrated Talks'. A. J. P. Taylor was already a well-known and controversial figure when he recorded his first television lecture series in 1957. In addition to his history output he had regularly written features for the *Manchester Guardian* and the *Daily Herald*. Through the early 50s his reviews appeared almost weekly in the *Guardian*, the *New Statesman* and the *TLS*. He appeared in debates on BBC Radio's Third Programme and had featured in a weekly TV discussion series called *In The News* in 1950. By the late 50s he was probably the most famous don in Britain. After giving the Ford Lectures at Oxford, producer John Irwin of ATV asked Taylor to lecture on television. The programmes proved an instant success. From 1957 to 1967 Taylor recorded one or sometimes two series of lectures every year, some for the Independent Television (ITV) network and some for the

A.J.P. Taylor delivers his lectures direct to camera, with trademark bow tie

BBC. Titles included *When Europe Was the Centre of the World* (ITV, 1957–8), *The Twenties* (BBC, 1962) and *Revolution 1917* (ITV, 1967). There was no set, just a black background. Taylor, wearing his trademark bow tie, walked carefully to his mark, looked up and spoke directly to camera. As with his Oxford lectures he spoke without notes, but always came to a perfectly timed conclusion with the assistance of a large clock behind the camera. He made more than forty television lectures in all and some of them attracted audiences of nearly 4 million viewers.[8] And certainly he can lay claim to being the first of what would be called the 'telly-dons'.[9] Taylor simply brought to the television studio the techniques he had learned in the lecture hall, and many legends have grown up around these quirky but brilliant TV lectures. At a time when there were only two, and then three, television channels they achieved an impact it is hard to imagine in today's multichannel world. But many

people claim their first interest in history was aroused by these early-evening television lectures – Simon Schama, for example, being one.[10]

The other star of this early form of television lecture was Sir Kenneth Clark. In 1933, Clark had been appointed as the youngest ever Director of the National Gallery and after the war became the Slade Professor of Fine Art at Oxford. For many years he had also been the Surveyor of the King's Pictures. During the 50s he was Chairman of the Arts Council and wrote extensively about the history of art. But despite his impeccable credentials and the feeling that he was a natural heir to the high-minded principles laid down by Sir John Reith for the BBC, in 1955 Clark took the controversial step of becoming Chairman of the Independent Television Authority (ITA), the body charged with overseeing the establishment of commercial broadcasting in the UK. Many saw him as a class traitor for selling out to commercial interests.[11] But after a two-year stint at the ITA, he went on to make some fifty lecture programmes for the ITV network. Clark had a populist streak in him, or at least he wanted to communicate his ideas to as wide an audience as possible, and he fronted several series for ATV, with titles including *Is Art Necessary?* (1958), *The Art of Landscape Painting* (1961), *Discovering Japanese Art* (1963) and *Royal Palaces* (1966).

So, by the early 1960s there were two clear traditions within Television History, that of the compilation film archive documentary and that of the presenter-led, authored, piece-to-camera 'Talk'. And the 'telly don' was an established figure on the television screen. In 1964 the BBC took this a significant step further with *The Great War*. About one in five history programmes through the 50s were about war and military history.[12] In 1962 the BBC started to think about how it would mark the fiftieth anniversary of World War I in 1964. The BBC *Tonight* (1957–65) team, based at Lime Grove and led by Alasdair Milne and Donald Baverstock, included many of the best and the brightest of the young generation of BBC programme makers. It was decided to turn their talents from the production of a daily magazine show to the making of a dramatic history series. The team was always looking for cheap sources of visual material and found this in the archive film held

9

at the Imperial War Museum. However, as the BBC was later to discover, there were problems in mandating a current-affairs team, accustomed to the priorities of a daily early-evening show, with the task of producing a major documentary series.

The Great War was a truly epic series in twenty-six forty-minute parts, produced by Tony Essex and Gordon Watkins. It was written by historians John Terraine, Corelli Barnett, Barrie Pitt and others, and narrated by Sir Michael Redgrave backed by the haunting music of Wilfred Josephs. Other leading actors read the words of prominent historical figures, Sir Ralph Richardson those of Douglas Haig and Emlyn Williams those of Lloyd George. The series was first transmitted in 1964, and it helped launch the BBC's new television channel, BBC2, transmitting on the new 625-line system. But the number of viewers who had sets capable of receiving the new system was very small and most people saw the series later in the year when it was repeated on BBC1 on the standard 405 lines. According to BBC folklore, pubs emptied on Wednesday evenings when the series was shown on BBC1.

The innovation of the series was to combine interviews with Great War veterans ('talking heads' in TV parlance) with archive film. In the previous year the Tonight programme had appealed for veterans with powerful memories of the war to come forward. When researcher Julia Cave started on the production she inherited thousands of letters to read through and had the task of selecting those to be interviewed. The veterans were in their sixties and still lively, energetic and forceful. But there was nothing spontaneous about the interviews. The comments of the veterans were thoroughly rehearsed in advance as filming took place on expensive 35mm film stock and had to be kept to a minimum. Nevertheless, their stories add great human impact to every episode. The veterans include some of the 'Old Contemptibles', members of the original British Expeditionary Force in 1914. They include Germans who endured the week-long barrage that preceded the Battle of the Somme and British survivors who went over the top at the start of that battle on 1 July 1916. There are soldiers who struggled through the mud of Passchendaele, who

drove tanks at Cambrai and who marched into Jerusalem behind Allenby. There are women from the Woolwich Arsenal and nurses who toiled at the Front. Most of them appear as an anonymous chorus of Everyman and Everywoman, without identifying name captions.

The Great War was broken down into bite-sized chunks of narrative which are easily digestible in television time-spans. The oral testimony along with intelligent scripts made for an outstanding series that combined human dramas with a 60s interpretation of the strategy of the war. The production team used a process at Kay Laboratories to step-print the archive film so that it looked crisp, sharp and ran at the proper speed (film from the silent era was shot at a different speed through the camera and usually looked jerky, comic and speeded-up when played back on sound projectors). Unfortunately, the producers freely intercut staged film footage shot after the war with authentic record film. This came from feature films like *All Quiet on the Western Front* (1930) and from a series of boy's-own type yarns shot by British Instructional Films on a set outside London in the 1920s. The amount of actual record film shot at the Front during the war was very limited and the BBC producers felt no shame in supplementing it with any staged material they could find. This included countless shots of explosions throwing earth and debris over the camera or shots that appeared to be taken from no man's land in front of advancing troops or looking straight down the barrel of a machine gun. In reality, no cameraman would have survived for seconds in such positions. This made for high drama but severely undercut the authenticity of the series. In addition, the producers conceived the bizarre notion that viewers would get confused by who was who, and so they tried to ensure that Allied soldiers, the British, French, Russians and in later episodes the Americans, all advanced from left to right. The other side, the Germans, Austro-Hungarians and Turks, were all made to advance from right to left. When the original film did not show this it was flopped-over so soldiers were seen moving in the 'right' direction. Experts ever since have counted the number of soldiers who advance with left-handed rifles. Although this went largely unnoticed when the series was first

11

shown it has been the source of much criticism ever since and has diminished the series in the eyes of many.[13]

Nevertheless *The Great War* was a turning point. The series proved that Television History could be serious, powerful and popular television. And it established the BBC as the natural home for this type of authoritative series. In 1967, the Controller of BBC2, David Attenborough, decided to take factual television in a new direction and persuaded Sir Kenneth Clark to produce a major series on the history of Western art and culture. Clark was reluctant at first as he realised how much time the series would take and he still had some book projects to complete, but he finally agreed once he knew the title of the series was to be *Civilisation* (1969). With producers Michael Gill and Peter Montagnon, Clark wrote and presented an epic of Television History. Made in colour to try to attract viewers to the latest technical revolution in television, the advent of colour broadcasting, the series was shot on 35mm film by a feature-film cameraman, Arthur Englander. It heralded a new genre of presenter-authored series not made like the earlier ones as studio-based Talks, but at locations around the world. *Civilisation* was filmed over a period of two years in more than 100 locations in thirteen countries. The series cost an incredible £500,000 but it did extremely well on American public broadcasting stations, which helped to recoup some of its costs. Follow-ups to this style of presenter-led programming were all made with US sales in mind. They included Alistair Cooke's *America* (1972) and Jacob Bronowski's *The Ascent of Man* (1973), both also produced by Michael Gill. All these series involved accompanying books written by their presenters that became bestsellers. Presenters could now find not only fame but also fortune by working on television. Alongside these major authored series were follow-up archive film and talking-head series like *The Lost Peace* (1966–7) on the history of the interwar years from 1919 to 1933. This thirteen-part series, produced again by Tony Essex, was made very much in the style of *The Great War*, even down to featuring Michael Redgrave as narrator. The range and quality of these programmes showed the BBC to be master of the genre of Television History.

Sir Kenneth Clark presenting *Civilisation*: filming took place around the world

It was while these developments were taking place in factual television that the young producer Jeremy Isaacs left ITV and joined the BBC. Isaacs was the son of Glaswegian Jewish, left-leaning, professional parents. His father owned a jewellery shop and read books endlessly. His mother was a doctor who was widely respected in the community she served. From Glasgow Academy he went to Merton College, Oxford where he read Classics and, not knowing what to do with himself after graduating, he managed to get a job in television. He started at Granada in Manchester as a general researcher in May 1958 on a salary of £18 a week.[14] He soon worked his way up the production ladder and began to produce *What the Papers Say* (1956), *All Our Yesterdays*, a popular current-affairs show called *Searchlight* (1959–60) and several one-off documentaries. In 1963, Cyril Bennett and Peter Morley at the London-based ITV company, Associated-Rediffusion, persuaded Isaacs to leave Granada in order to edit the weekly current-affairs show *This Week*

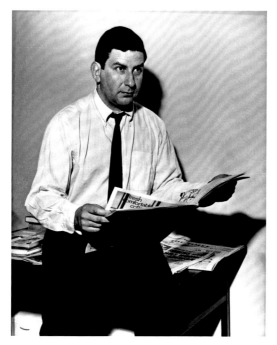

Jeremy Isaacs in the mid-1960s: he went from ITV to the BBC and back to ITV

14

(1956–92). He toughened up the content and the format of *This Week* and the ratings of the strand increased considerably. After two years, with his reputation rising, he was approached by Paul Fox, the Head of Current Affairs Group Television at the BBC and asked to become editor of the flagship series *Panorama* (1953–). It was very unusual at this time for producers or executives to move from ITV to BBC but Isaacs now found himself hired to revive a flagging programme transmitting every Monday night in the fifty-minute slot that preceded the *Nine o'Clock News* (1970–2000).[15]

 Isaacs introduced changes to liven up *Panorama*. He brought in a new title sequence with a montage of faces cut to a theme from Rachmaninov. He used new 16mm film technology to produce more mobile, fresh and sometimes handheld reports from distant spots. He chronicled the disasters in Vietnam and the failure of British industry to

modernise. It was on his watch that Richard Dimbleby, the veteran frontman, died of cancer. A dispute arose over who should succeed him. Isaacs argued for a new format, replacing studio-based interviews and discussions, and that *Panorama* should consist of a single-issue film report. His arguments won the day and in the autumn of 1966 *Panorama* shifted to a forty-minute slot after the news. But Isaacs was not good at playing the labyrinthine game of BBC politics. Mines were laid across Lime Grove and Isaacs stepped on them. He spent eighteen months gathering a group of distinguished reporters and directors around him and edited several fine episodes of the BBC flagship. But at the end of 1966 the dispute with the BBC management over how *Panorama* should be structured blew up in his face. Paul Fox informed him of the decision to return *Panorama* to a multitopic format. Isaacs felt he had no alternative but to resign. He left the BBC in January 1967 literally with tears in his eyes. Perhaps his television career was over. But on the following day he telephoned Cyril Bennett at his old company, Rediffusion. Bennett immediately agreed to meet and said he could definitely find a job for him back at ITV. Early in 1967 Jeremy Isaacs, then aged thirty-four, returned to Rediffusion as Head of Features.[16]

15

3 ITV

The ITV network had been established in the mid-1950s not as a surrender by the Conservative government to commercial interests but as a typical British compromise. The Reithian concept was that public-service broadcasting, first radio and then television, had a highbrow mission to educate, inform and, as a poor third, entertain. This mantra had governed the running of the BBC since the 1920s. Moreover, the corporation had established its independence from government and it valued this as paramount at all times, except during the crisis of World War II when government control over parts of its output was willingly accepted. But by the mid-50s there was a widespread feeling that a more popular alternative was needed. However, there was little enthusiasm for the model provided by American broadcasting where there was a commercial free-for-all dominated by a tiny group of national broadcasters. There, the interests of the advertisers reigned supreme, and the broadcasters appeared, from across the pond, to produce nothing but a diet of quiz shows, sitcoms and Westerns. So the answer was to combine the concept of public broadcasting with commercial interests.

The government decided to break the BBC's monopoly but did not want to resort to the public purse to finance the new system. Funding would come from advertising revenue, and a new body was established by Parliament, the Independent Television Authority to regulate the system. Companies had to apply for a franchise to hold a licence and their shareholdings and financial interests had to be

approved by the ITA. The regulatory body also imposed strict controls on what could be broadcast, ensuring a diet of documentaries, news, current affairs and religious programmes was transmitted alongside the populist fare of light entertainment, soaps and quiz shows. As one of the official historians of ITV noted, this was 'an arranged marriage between public authority and private enterprise ... not commercial television but semi-commercial television'.[17] Indeed, in many ways the BBC and ITV represented two sides of the same public-service broadcasting coin, both heavily regulated in the public interest, one funded by a compulsory licence fee, the other by advertising.

The ITV network was, in addition, to be made up of regional companies with strong local roots, ensuring a diversity of output that would truly reflect some of the differences within the nation. Most viewers knew ITV through the brand of their local supplier. So when ITV went on air from 1955 the network was dominated by a small group of four companies: Associated-Rediffusion from London was first on air, Associated Television or ATV from the Midlands came next, then ABC Television, also London-based and, finally 'from the North', Granada. A separate company, jointly owned, Independent Television News (ITN), provided the national news service. The popularity of the new channel was such that within a few years slightly more than two-thirds of the growing television audience had abandoned the BBC to watch ITV. The BBC responded in the early 1960s by improving its game and fighting back. By 1963 the BBC and ITV both commanded a roughly equal fifty–fifty audience share.

Running an ITV company was always going to be a strange sort of business. The companies produced one thing, programmes. But they sold something else, advertising. And the ITA controlled all aspects of their business operations, including the composition of the boards of directors. After heavy initial losses incurred in setting up shop, the ITV companies finally started to make profits during the 60s. Roy Thomson, the owner of Scottish Television, used the much repeated phrase that ITV was a 'licence to print money'. Indeed, by comparison to today when television advertising revenue is divided between several hundred

17

commercial broadcasters, it might well be imagined that, with all television advertising scooped up in a single basket, this was indeed the case. But it was never quite as simple as that. Mindful of the profits being made by companies that were often associated with the values of popular entertainment, the government imposed a new tax on the ITV companies. In addition to Corporation Tax, which all companies had to pay, a Levy was introduced in 1964. This was paid not on profits but, uniquely for a business tax, it was to be paid as a percentage of revenue. Each contractor had to pay a sum of up to 45 per cent, depending upon the size of its advertising revenue, directly to the Exchequer as a form of duty for the privilege of holding an ITV licence.

In 1967, the licences held by the existing ITV companies came up for renewal. The ITA decided to make significant changes to the structure of the network. In the following year two new companies appeared and one of the existing majors had its wings severely clipped. Out of Rediffusion[18] and ABC Television came a new company, Thames Television, which had the licence to broadcast and sell advertising in the London region from Monday through to Friday afternoon. London Weekend Television (LWT) was a new creation, broadcasting in London on Friday evenings and across the weekend. The northern part of the Granada franchise was awarded to another newcomer, Yorkshire Television. The five 'majors' as they were called (Thames, London Weekend, ATV, Granada and Yorkshire) all served major centres of population and had the obligation to make nationally networked programmes. There were five large regional companies (Anglia, Harlech, Scottish, Southern and Tyne Tees) and five small regionals (Border, Channel, Grampian, Ulster and Westward). ITN continued to furnish the national and international news.

Thames Television, serving a London population of more than 14 million people for four and a half days a week, became the largest programme maker in the ITV network. It was formed out of the shotgun merger between the two previous London-based companies, Rediffusion and ABC. Merging two companies with two managements and two staffs proved tricky. From ABC, which had a slight majority of shares in

the new company, came the new Managing Director, Howard Thomas, and the new Director of Programmes, Brian Tesler. ABC, with hits such as *Armchair Theatre* and *The Avengers* (1961–9), had traditionally been good at drama and entertainment and so provided the core of these new areas at Thames. Rediffusion, with *This Week*, had been good at current affairs and documentaries and delivered these core areas for Thames. Programmes like the Rediffusion quiz shows *Double Your Money* (1955–68) and *Take Your Pick* (1955–68) disappeared from the ITV schedule.

But ITV still had what could be called an image problem. From its earliest days it had been most associated with cheap, low-grade programming, and with entertainment shows like *Sunday Night at the London Palladium* (1955–67) and with what became the long-running soap *Coronation Street*. In the early 60s the Pilkington Committee was highly critical of its output and allocated the third channel to the BBC in what became BBC2 in 1964. After the franchise reallocation in 1967 chaos erupted in the ownership and management of LWT. The Free Communications Group, a lobbying coalition of dissatisfied journalists and television producers, headed by Neal Ascherson of the *Observer*, called for social ownership of the means of communication, in both the press and television. In the distant future there was the possibility of a fourth channel. ITV needed to be able to show that it could run it. With critics everywhere, the new face of ITV in the 70s needed desperately to prove that it could produce high-quality programming to rival anything that could be done at the BBC.

Jeremy Isaacs returned to Rediffusion six months before the announcement that the company had lost its franchise and faced merger. Many talented programme makers had left the BBC to follow him to Rediffusion. He didn't know Brian Tesler who would be programming head at the new company but it so happened that both men lived in Chiswick. Isaacs used to walk his children in the local park on Sunday mornings. Tesler did the same. Isaacs made a point of meeting Tesler in the park and told him that if as Director of Programmes he could guarantee the continued existence of *This Week* in a primetime slot,

19

Thames Television went on air in July 1968

furthermore if he could agree to the establishment of a daily local news programme and the making of a monthly network documentary, then Isaacs would bring his whole department with its bevy of talented film-makers to the new company. Probably mindful of the fact that Thames was going to need Isaacs and his factual programme-making talents, Tesler agreed there and then.[19]

On Tuesday 30 July 1968 Thames Television went on air with a quirky ident revealing the London skyline and a catchy musical jingle. On that first night the screens went black during a Tommy Cooper show due to a technicians strike called by the ACTT union. It was not a good start. It took some time for the new company to bed in but before long it proved popular with the millions who watched and enjoyed its output. The audience share of Thames's programmes increased during 1969 and into 1970. By the spring of 1969, Thames boasted 78 per cent of London's ten weekday favourites against the BBC's 22 per cent.[20]

As Head of Features and Children's Programmes, Isaacs had a large output to oversee. Within his remit was the new, four-days-a-week, early-evening local news show called *Today* (1968–77). Tesler introduced Eamonn Andrews to Isaacs and he presented *Today* for some time. The programme helped to set the tone for the new station. There was also the weekly edition of *This Week* and in addition the regular

20

output of major documentaries to oversee. Then there were children's programmes made at an old studio complex that Thames had inherited from ABC at Teddington Lock. These included a new magazine programme to rival the BBC's *Blue Peter* (1958–) called *Magpie* (1968–80). It was a vast programme-making empire to rule over. But Isaacs had fine lieutenants. Andy Allan joined from ITN to run *Today*. Phillip Whitehead, who had left the BBC to follow Isaacs to Rediffusion, edited *This Week*. Lewis Rudd oversaw the output of the children's programmes. Isaacs had a knack for attracting key talents and inspiring them to think up and produce great programmes.

Thames had an unlikely hit in its first year on air with a big documentary series it had inherited from Rediffusion called *The Life and Times of Lord Mountbatten* (1968) produced by Peter Morley and written by John Terraine, one of the writers of the BBC's *The Great War* series. Lord Mountbatten was an uncle of Prince Philip and very close to the royal family. He had led an extraordinary career. As a naval officer he was captain of HMS *Kelly* when it went down in the Mediterranean

21

Lord Mountbatten presenting his *Life and Times*, an early hit for Thames

in 1941, a story immortalised by Noel Coward in the movie *In Which We Serve* in 1942 (Coward himself played the captain). He was Chief of Combined Operations and then Supreme Commander South East Asia. After the war he was the last Viceroy of India and oversaw the transition from the British Raj to independence for India and Pakistan. Rediffusion had made a lavish twelve-hour series based on his life, with archive film and talking heads, rounded off by none other than Lord Louis himself, who was never modest about describing his important role in the remarkable events of his life. To launch the series, Thames previewed episodes at the Imperial War Museum in December 1968. In a dazzling, star-studded launch, the Queen and Prince Philip turned up. The Prime Minister and all the military chiefs of staff were there too. Howard Thomas, as managing director of the company that was only a few months old, gloried in the royal imprimatur. Thomas had once been the head of British Pathé but he was sceptical that the ITV network could sustain a long-running history series. To his surprise, and to that of many others, the series was a resounding success. Seven episodes rated in the London Top Ten and one episode hit the No. 1 slot. It proved that a well-made history series on a popular subject could hold an audience in a primetime ITV slot. Thomas, Tesler and Isaacs, none of whom had had anything to do with the making of *Mountbatten*, were left pondering the lessons of this.

22

4 The Decision

With the strength of the BBC's record in history programme making, and the fact that they had produced a series on World War I, *The Great War*, and then *The Lost Peace*, on the interwar years, it was inevitable that programme executives at the Beeb would start to think about making a series on World War II. There had been discussion of the idea within the *Tonight* team but the formidable Head of Current Affairs Grace Wyndham Goldie had pronounced that it was too soon after the war to contemplate such a project.[21] The historian Arthur Marwick taunted the corporation in the pages of the *Listener* in May 1969, asking why the corporation had appeared to reject the idea of a World War II series. He suggested that it was because Tony Essex, the producer of both *The Great War* and *The Lost Peace*, had left to join Yorkshire Television and that the BBC would not dare produce a big series without his 'practised hand'.[22] Derrick Amoore, the Assistant Head of Current Affairs, responded by writing that a World War II series was 'still being actively pursued', at the BBC. He claimed that they were working 'on ways of financing the series', which would be a 'difficult business'.[23]

It was at about this time that Amoore approached Jeremy Isaacs at Thames. Although Isaacs had left the BBC under a cloud only a few years before, Amoore told him that the BBC was thinking of doing a big history of World War II and asked if he would be interested in producing it. Isaacs replied that he was certainly interested but that he was busy at Thames enjoying the task of building up the Features Department. Isaacs's interest later diminished when he discovered that

others had been asked to produce the series as well.[24] One of those was
Peter Morley with John Terraine. Peter Grist, Amoore's boss in Current
Affairs at the BBC, took Peter Morley out to lunch and told him that he
and Terraine would be the ideal pair to make a BBC series on World War
II. He explained that there was a delay in committing to this, not for
financial reasons as had been publicly put out, but because Paul Fox
(who was now Controller of BBC1) felt that, with the recent launch of
colour television, all BBC resources had to be committed to colour
programming. Inevitably, a series on World War II would consist largely
of black-and-white archive film and Fox was not sure that the time was
right to invest heavily in such a project.[25]

For whatever reason, the BBC hesitated and failed to commit.
But the idea of making a big series was out there and had started Isaacs
thinking at Thames. At this point another key figure in the genesis of the
World War II series, Peter Batty, enters the frame. After Bede Grammar
School and Oxford, where he read Philosophy, Politics and Economics

Peter Batty at his desk; he submitted an idea for a World War II series and
went on to direct six episodes of *The World at War*

or PPE, Batty had started his career as a journalist working for the *Financial Times*. In 1958 he joined the BBC and, with Donald Baverstock, Alasdair Milne, Tony Jay and a group of bright young programme makers, he had worked on the hugely influential early-evening magazine show *Tonight*, presented by Cliff Michelmore. By 1963, he had risen to the role of editor, but had never been fully happy in charge of a current-affairs show, preferring to work as a film-maker on his own projects. So, in the following year he moved to ATV as executive producer of documentaries. There, Lew Grade explained that his brief was to 'win awards' for ATV in the runup to the franchise renewal. Batty produced many documentaries for ATV including a film about the Krupp family and, in 1967, a film to mark the 25th anniversary of the Battle of El Alamein. In 1968, Batty left ATV to go freelance. He made a film for the BBC about the battle for Monte Cassino and in 1968 started to work also with George Moynihan of Westinghouse TV in the United States, who paid the considerable sum of $30,000 for the US rights to some of his films. Working as a prototype independent producer, he made a series of documentaries about the war that were funded partly by Westinghouse dollars and partly by the BBC. Batty was another who had been taken out to dinner by Amoore on more than one occasion and sounded out on producing a World War II series. So he, too, was aware of the BBC's much delayed plans for such a series.[26]

25

Frustrated by the BBC's inability to commit, Batty wrote to Brian Tesler at Thames on 9 January 1970 suggesting that the time was right for a World War II series. He pointed out that the 'generals and other principals are popping off' and that 'someone ought to be getting their stories down on film before it is too late'.[27] Batty suggested that this should be an ambitious project of twenty-six one-hour episodes. Tesler invited Batty to meet with Jeremy Isaacs under whose remit such a series would fall. On 14 February, Batty pitched a short two-and-a-half-page outline of a possible series to Isaacs. He called it a 'skeleton' for the series.[28] Isaacs met with Batty for lunch on 12 March to discuss the idea. But Isaacs felt that Batty's approach was too focused on a military

history of the war. Although war-history buffs might love it, it did not contain enough about the civilian experience of living through what had been a 'total war'. On 12 May 1970, Tesler wrote to Batty formally rejecting his proposal for a World War II series, saying that with an established and fully staffed Documentary Department, Thames 'cannot afford to embark on a project of such a size', which Batty effectively wanted to make out of house as an independent producer. Tesler concluded that if the economic conditions changed 'I will come back to you rather than any other free-lance[r]'.[29]

During 1970, Batty started production independently on a film about Operation Barbarossa, the German invasion of the Soviet Union, to be shown on the thirtieth anniversary of the invasion in the following year. It was funded with American money through Westinghouse TV but Batty hoped to sell it later to a British broadcaster as well. During production of the documentary, Batty met with Stanley Forman, who had excellent links with film archives in East Germany. Forman's company ETV (Educational Television) provided Batty with some outstanding footage of the war in the Soviet Union that had never been seen in the West before. Batty also approached Albert Speer, Hitler's architect and wartime Minister of Armaments and one of the few surviving leading figures from the Nazi government. He had just been released from twenty years' imprisonment as a war criminal and, to Batty's surprise and, delight, agreed to be interviewed for the documentary.

Meanwhile Isaacs had begun to think more carefully about a World War II series. He knew what he didn't want, a purely military history of the war, and slowly he began thinking about how he would go about producing such a series. He wanted something more ambitious and hopefully more popular about how men and women around the world had lived through the years of war. He wondered if he could go it alone and produce something himself at Thames, rather than produce it at the BBC with its many layers of management.[30] The problem was that ITV was going through a bad patch. The increased cost of the conversion of studios and transmission facilities to colour television, along with the poor state of the economy that resulted in a decline in advertising

revenues, had seriously dented the profits of the TV companies. Moreover, there was the lingering issue of the Levy. In its first year, Thames earned advertising revenues of £15.1 million. Out of this it paid just over £5 million to the Exchequer as a Levy (33 per cent). From the remaining £10 million it paid all production and technical costs, all overheads and a rental to the ITA. After dividend payments, it carried forward only a tiny profit of £5,609. The Chairman of Thames, Lord Shawcross, argued that the Levy payment was totally unfair and would reduce the profits of the ITV companies to the level at which programme standards would start to decline. Shawcross expressed the view of all the ITV companies when he argued that a Levy payable solely upon income without any deduction for the costs of earning that income represented a system that was 'wholly wrong in principle'. He said that if the current trends in the economy continued then ITV companies would end up making losses while still paying huge sums to the Exchequer.[31]

In June 1970 Edward Heath and the Conservatives won the general election and replaced Harold Wilson's Labour government. It was the Conservatives who had set up the ITV system in the 50s and they were thought to be more sympathetic to commercial interests. So the ITV companies lobbied hard for a change in the way the Levy was raised. On 15 February 1971 the Minister for Post and Communications, Christopher Chataway, made a statement in the House of Commons. First he announced that, in order to prevent the BBC from having to make severe cuts in its services, the licence fee would increase by £1 to £7 for a monochrome and £12 for a colour licence. He then went on to make the momentous announcement that the government would review the basis on which the Levy was to be charged and that it was mindful to make the Levy payable on profits rather than on revenue. In the meantime he announced an immediate halving of the Levy. This meant instant relief for the ITV companies with the prospect of a long-term change to what they regarded as a more equitable basis for this additional form of taxation. *The Times* speculated that for Thames this would not only reduce Levy payments by roughly one-half, but that this would also result in a net pre-tax

saving of nearly £1.4 million a year.[32] Sudden savings on this scale were a cause for celebration at all the ITV companies. The Minister had added one condition, that if the long-term change in the Levy were to go ahead, the money saved must be spent on programme production and not on diversifying into bingo halls or motorway service stations, as some ITV companies were doing.

Only a few days before the momentous government announcement, Isaacs had received another letter to his home address from Derrick Amoore at the BBC, apologising for the delay in the decision to commit to a series on World War II. Amoore wrote that the computers that worked out the finances had got into 'a considerable muddle' and that it would not be until April that the BBC would know if it could fund the series. 'I'm sorry – again – to muck you about like this,' he wrote, 'But it seems a bad time of year for decision-making all round.'[33] On the same day he wrote to Peter Batty to apologise to him for further delays.[34] Both men had lost faith in anything that Amoore said and both suspected that he was talking to others. But Isaacs knew that there was a possibility that the BBC would go ahead with a history of World War II in a few months time.

Jeremy Isaacs read the news of the government's plan to reduce the Levy on the afternoon of the announcement in the *Evening Standard*. He went straight down the corridor to his boss Brian Tesler and said that the time was now right to commit to the big, ambitious World War II project. If the production costs could be offset against the Levy payment, then the real costs to Thames of producing such a series would be drastically reduced. Tesler went immediately to Howard Thomas, the Managing Director, with the idea. Within twenty-four hours the decision was made. The World War II series would go into production as soon as possible. The board was not consulted. The other ITV companies who would have to agree to give up twenty-six primetime slots were not consulted – that would come later. There was not even a written proposal for the series.[35] But several factors had come together. The success of *The Life and Times of Lord Mountbatten* had shown that history could work on ITV in primetime. The delays at the

Brian Tesler, Director of Programmes at Thames when the decision was made to produce *The World at War*

BBC over several years meant that the most obvious broadcaster to make a World War II series had not yet decided to go ahead. But Isaacs knew through the personal approach that had been made to him that this decision might be only months away. Thames was an ambitious young company keen to demonstrate that it could make quality programmes on a par with anything the BBC could produce. Now it had been handed a sudden windfall from the government with the halving of the Levy, as long as it spent the money on production.

Such was the sudden buoyancy at Thames after the government's announcement that Howard Thomas, Brian Tesler and Jeremy Isaacs made the decision between them to go ahead with the biggest factual series that ITV had ever produced. Now, the race was on to announce the series and to get it out in the public domain before the BBC got its act together and announced its own series.

5 Announcement

Jeremy Isaacs's first priority in the rush to launch the World War II series was to give it sufficient credibility to knock any rival project out of the running. For this, he felt he had to get a top historian on board, a 'name' whose support would show how serious the Thames proposition was. Isaacs did not want to listen to contrary advice from a number of historians or proposals from an editorial board. For Isaacs, a single principal figure would be sufficient and there was one obvious candidate.[36] So, on Tuesday 9 March 1971 he met with Dr Noble Frankland, the Director of the Imperial War Museum. He would come to play a major role in the production. Frankland had been educated at Sedbergh and at Trinity College, Oxford. During the war he had served in the RAF as a navigator in Lancasters of Bomber Command. He had flown thirty-four bombing missions over France and Germany in 1944. He had been shot at by enemy fighters and anti-aircraft gunners innumerable times and on one occasion the fuel in the wing of his Lancaster had been ignited by fire from an enemy fighter and the crew just made it back to crash land near the south coast. Having survived these harrowing experiences, Frankland returned to the quieter life of academe, but then from 1951–8 worked with Sir Charles Webster at the Cabinet Office on the official history of the strategic bombing offensive. The four-volume history they produced proved highly controversial as it pointed out the substantial failings of the bombing offensive and why, until quite late in the war, Bomber Command had been able to do little more than carry out the area

bombing of German cities, killing and wounding tens of thousands of civilians in the process.

Despite this controversy, in 1960 Frankland was appointed Director of the Imperial War Museum. At that time, the IWM was a rather out-of-the-way spot with a reputation for glorifying war and known for the antiquated style of its galleries, with rows of models, maps and medals in glass cases. Over the following decade Frankland transformed the museum. He put it on the map as an attraction with a range of exhibitions that brought in visitors by the thousand. He turned around the reputation of the museum by establishing the academic credentials of its work. And at the end of the decade he began to recruit a new generation of younger staff that would lead the museum for the next forty years.

The jewel in the crown of the museum's many collections was its vast film archive, the oldest public film archive in the world, that had been in existence since the end of World War I.[37] Frankland brought the museum into the television age by working with various TV productions but these were not always happy experiences. He acted as consultant to the BBC's *The Great War* series and had offered the BBC a very favourable deal when it came to using IWM archive footage.[38] As we have seen, *The Great War* was produced by the *Tonight* current-affairs team, which was used to quick turnarounds and not accustomed to taking into account the advice of outsiders. Frankland was outraged by the way the production team behaved towards him. Most commentaries were recorded before he had been given an opportunity to read them. Cuts of the film were shown to him only a day or so before their transmission. There was no time to implement or even listen to his comments. Frankland seriously objected to the way the archival film was used in the series and to how reconstructed or faked scenes were freely intercut with authentic footage with no differentiation. He fell out so badly with Tony Essex, the producer, and regarded his treatment as such a 'disgrace' that he complained to the Director-General of the BBC, Sir Hugh Greene. The D-G asked Grace Wyndham Goldie to carry out an investigation but nothing was changed in the body of the films when they were later repeated on BBC1, other than that each episode was

preceded by a caption saying that some scenes had been reconstructed. Frankland was so annoyed that he 'dreaded the prospect of working again with Tony Essex' when he heard talk of a BBC series on World War II. He went even further by doubting if he 'would have risked associating the Museum for a second time with a production of his'.[39] That the Director of a major national museum should seriously contemplate withdrawing support for the national broadcaster on a future project because he doubted the integrity of its producer was a sign of how badly Frankland felt he had been treated.

The making of *The Life and Times of Lord Mountbatten* by Peter Morley and Rediffusion had also involved close collaboration with the IWM film archive. This was a far better experience for Frankland himself and he was delighted to be asked to introduce the films at the royal premiere held in the IWM cinema. But he was still suspicious of television producers and of how they might rip off both himself and IWM collections. This was still Frankland's view when Jeremy Isaacs walked into his office on 9 March 1971.

32

Frankland immediately felt that Isaacs was a completely different type of producer to Essex. He later wrote that never again in his career did he encounter a producer 'of such brilliance and integrity as characterised Jeremy Isaacs'.[40] Frankland stated from the outset that unless Thames was going to use archive film authentically he did not want to be associated with the project. He argued that precision and integrity when using sources was no less important for a television producer than it was for a historian. Isaacs immediately responded and agreed with this. They discussed the range and ambition of the project and Isaacs explained that he wanted to include the civilian experience of war as well as cover the military history. Isaacs asked Frankland to write down fifteen military topics that any series on World War II could not ignore. Later Isaacs claimed that this was written down 'on the back of an envelope' but this was a metaphorical reference. No such envelope existed.[41] As they talked, the two men got on well. Isaacs asked Frankland at this meeting if he would agree to act as principal adviser on the series. Frankland agreed to consider this.

On 16 March, Isaacs wrote to Frankland summarising their meeting and outlining his plans.

> We shall seek to combine an account of the military strategy of the war with the experience of those who fought and suffered in it … . We shall use historical film to a very large extent, and will also be collecting the memories and opinions of those who took part in the war and were eye-witnesses to its events. We shall hope to make considerable use of the facilities of the IWM and of other major film libraries of the world … . But the purpose of this letter is to invite you, in your private capacity as a historian, to act as principal adviser to the series.

Isaacs went on to explain that he would want Frankland

> to comment on the outline of the series, and on individual scripts as they become available, to point us in the direction of those best able to help us on particular issues, to give guidance yourself on your own particular speciality, and above all to help us to ensure that in our films we make use only of authentic historical material, or at any rate distinguish clearly between actual eye-witness film footage and any reconstructed or invented material which we might feel it necessary to use for a particular purpose.

Isaacs went on to offer Frankland a fee of £2,000 for his personal involvement spread across the two years it would take to make the series. Using an average earnings index this is roughly equivalent to about £25,000 in 2012 terms, a substantial sum for a television adviser then and now.[42] Isaacs concluded:

> I expect to be in a position to make a public announcement about the project in the next week and, if you have no objection, would like to mention then that you have agreed to advise us.[43]

This letter is a fascinating document. It shows that many of the core elements that would mark out *The World at War* had been thrashed out

in this first meeting between the young, ambitious television producer and the experienced but sceptical museum Director. The series would forever be known for its authentic use of archive film, and for its universal and not purely military approach to the war. Frankland replied to Isaacs on 23 March saying that he 'gladly' accepted the offer. He stipulated two conditions, that his acceptance of the personal role as principal adviser was 'separate from what the IWM will decide about its participation in the series'. And he made it clear that at all times his first responsibility was to the museum as its director.[44] Isaacs's seduction of Frankland had worked. He now had his 'name', he just needed one further item in place before he could make a public announcement about the series.

The man in the Thames Features Department who handled the money was Roy English. There had never been a production on this scale before but somehow English had to come up with a budget quickly which the team would need to stick to for two years. Making some basic assumptions, for instance, that approximately 70 per cent of the final running times would be made up of archive film and 30 per cent of specially shot interview material, and that each episode would take roughly two months to edit, English started to do the calculations. Guessing the costs of clearing all the archive film from libraries around the world and then processing it through the laboratories was almost impossible. Nevertheless, English made a stab at it. At this time, in accordance with industry-wide custom and practice, television budgets were only costed above the line. Overheads, including staff salaries, office costs, cutting-room hire, cameras, equipment and so on were not included. What needed to be budgeted were cash costs, that is how much it would cost to pay for the film stock, for the processing of the archive film, the travel for the production team, etc. One exception was overtime for film crews and editors – that was also to be included as a cash cost. English estimated that, as nearly all the filming would be interviews and all the editing was to be done over a long period, there would be a negligible need for overtime. As he started to run the figures through his calculator it was clear that this was going to be an extremely

expensive series. He realised there would be little funding available for big-name directors, an above-the-line cost. The senior members of the team would have to be staff or long-term freelancers as their salaries would be below the line. English came up with a budget of £440,000.[45] This is approximately equivalent to £5 million in 2012. But could Isaacs keep to this?

On 31 March 1971, a press conference was held at Thames Television's new offices on the Euston Road. Howard Thomas, the Managing Director, kicked it off by announcing the twenty-six-part series on the history of World War II as 'the most ambitious documentary series ever produced by commercial television in Britain and the most expensive'. He said it would cost about £500,000 and claimed that Thames had been sitting on the idea for eighteen months. This was rather an exaggeration. Peter Batty's first proposal had come in fifteen months before, in January 1970, although of course this had been rejected. Thomas made it clear that only since the government had revealed its plans to reduce the Levy on the ITV companies had it been possible to find the money to make such an ambitious series. Introduced as the producer of the project, Jeremy Isaacs declared that there would be five producer-directors and six writers on the series. He explained that the series would draw on film archives in Germany, Russia, France and America as well as Britain and that he was particularly anxious to portray the war from the Axis point of view as well as from the more familiar Allied angles. Noble Frankland was officially named as principal historical adviser to the series. It was a real coup to attach him to the announcement and with him, by implication, the support of the Imperial War Museum. Isaacs added

> We shall appeal to two entirely different audiences. There will be those who vividly remember the war and the far more difficult audience of those under 30 who do not recall it at all but whose lives have nevertheless been strongly affected by it.[46]

Widely reported in the press, the announcement represented a big hurrah for independent television.

On the evening before the announcement, Isaacs had sent a courier to the home of Peter Morley. He knew Morley well from *The Life and Times of Lord Mountbatten* and he knew that Morley and John Terraine had been offered the chance (as he had himself) of producing a World War II series for the BBC. Out of frustration at the BBC's indecision, Morley had also discussed a World War II series with Isaacs, along with a proposal with John Terraine for a film about propaganda in war called *The First Casualty*. The message Isaacs sent said he wanted Morley to know before it became public knowledge the following morning that Thames was going to start work on a twenty-six-part history of the war. He added

> I regret having had to be so secretive about this, especially as you confided in me. But I knew before talking to you of the possibilities at the BBC. (Indeed it was partly being approached myself and then left dangling which made me realise that Thames could do this on its own.)[47]

Morley was gutted. He saw the prospect of producing a major series for the BBC collapse. He called Terraine, who was 'deeply shocked, almost speechless'. Then he called Paul Fox, the Controller of BBC1 who had delayed the BBC decision to go ahead with the project. He was out at a football match. When Fox called him back at about midnight he too seemed distraught. 'I'm not prepared to talk about it, Peter', Fox said. 'Give me a few days and then try again.' Morley could almost hear the egg dripping off Fox's face. Through all its delay and prevarication, Auntie BBC had been humiliated. The brash young upstart, Thames Television, had got there first.

6 The Treatment

At the time of the public announcement there was still no written
proposal or outline for the series. Jeremy Isaacs now set to and began
writing up a Treatment for the project. He sent a first draft of this to
Noble Frankland, his principal adviser, on 28 April 1971. The
Treatment runs to eight pages and this is the first document to outline
the series, episode by episode, in a form that is very close to the finished
production. Isaacs's vision of the series is remarkably clear even at this
early stage. Isaacs admits that he was no historian and certainly no
military historian at this point. He had not read extensively about World
War II.[48] He had seen Peter Batty's earlier outline but had rejected it.
And he had discussed the whole project with Frankland and agreed the
general approach with him. But his first Treatment displays a clear grasp
of how he wanted the series to flow.[49] Isaacs writes in a tight, concise
style. His Treatment is not a set of essays or even paragraphs but is a
punchy rat-a-tat-tat summary of the key issues each episode will cover,
like a machine gun spitting out bullet-point ideas and pieces of history.
Most episodes have a short one- or two-word title. Isaacs liked brevity
of expression.

 The first six episodes in this initial Treatment are very much as
the first six episodes of the final series turn out. The first programme
deals with Germany before the war and the rise of the Nazis, ending
with Hitler's invasion of Poland and the declaration of war (in the series
titled 'The New Germany'); this is then followed by one about the war
in Poland and the Anglo-French preparations for war (in the series

Thames Television Limited
Thames Television House
306 Euston Road
London NW1 3BB
01-387 9494

28 April 1971

Dr. Noble Frankland,
Imperial War Museum,
Lambeth Road,
London S.E.1.

Dear Noble,

Here is my first attempt.

You will see at once that a very great deal is omitted, and not
only particular campaigns, but also some themes - The Neutrals,
Propaganda, Prisoners of War - for which I would have liked to
find room.

I attempt to deal with the subject matter thematically. But I
also want to preserve for the viewer of the series a sense, not of
detailed chronology, but very definitely of the overall development
of the war. It is therefore extremely important where precisely
within the order of transmission we place particular themes. For
example, a battle of the Atlantic in '41/42 in the order is bound
to be different from the same theme placed in '43. Here there is
undoubtedly considerable room for manoeuvre. For I want to preserve
so far as I can the sense that somehow each programme picks up where
the previous one left off.

Anyway, on all of this I shall be grateful to hear from you what
you think of this scheme. And utterly frankly, please. And as
soon as you possibly can.

All good wishes.

Yours sincerely,

JEREMY ISAACS
CONTROLLER
FEATURE PROGRAMMES

P.S. I have asked Mr. Norman Musbe in our Contracts Department to
write to you at your home.

Grams Thamestel London NW1
Telex 22816

Thames Television Limited

Directors:
Lord Shawcross PC QC (Chairman)
Howard Thomas CBE (Managing Director)
George A. Cooper

D. R. W. Dicks
H. S. L. Dundas DSO DFC
Bernard R. Greenhead OBE
Clive May FCA
Brian Tesler MA
Humphrey Tilling

The letter from Jeremy Isaacs to Noble Frankland accompanying the first
series Treatment

'Distant War'); an episode on the Blitzkrieg invasion of northern France and the Low Countries (in the series 'France Falls'); one about Dunkirk and the Battle of Britain (in this Treatment called 'Finest Hour' but in the series titled 'Alone'); a programme on the widening war with the German invasion of the Soviet Union (here and in the series titled 'Barbarossa'); and an episode about the rise of Japan, Pearl Harbor and the Japanese offensive in southeast Asia (in the series 'Banzai!').

At this point in the series breakdown, the order in the Treatment differs from the final running order, although many of the outlines are recognisable as episodes in the final series. For instance, there is a programme on the war in the Atlantic (in the series 'Wolfpack'); an episode asking what was it like to live inside Hitler's Germany (here and in the series titled 'Inside the Reich'); one on the Home Front in Britain and the People's War (called here and in the series 'Home Fires'); an episode about the United States marshalling itself for war as the arsenal of democracy (here called 'The Yanks Are Coming' but in the series titled 'On Our Way'); a programme about the North African desert war ending with the Battle of El Alamein (in the series 'Desert'); an episode on the turning-point Battle of Stalingrad (in the series 'Stalingrad'); and one on the strategic bombing of Germany (in the series 'Whirlwind'). Episodes 14 and 15 in this first Treatment are two programmes that, for reasons that will become clear later, were never made. One called 'Big Three' is about the statesmen who led the Allied war effort, Churchill, Stalin and Roosevelt. The second, called 'Hitler's Generals', explores what it was like to be in Hitler's war room and how his generals argued with a dictator.

The Treatment then continues with a set of programmes that, although in a different order, are again totally recognisable in the final series. One episode looks at the continuing struggle on the Eastern Front (in the series 'Red Star') and another examines the debate about opening the Second Front (in the series 'Morning'). There is one about what it was like to live under German military occupation here called 'Occupation – Resistance'. As production continued it was resolved that this should focus on a single country and it was decided to make this

film about the Netherlands. It was finally titled simply 'Occupation'.
Then follows an episode following the Allied advance from Normandy
to the Rhine. This finally became a programme looking at the advance
towards Germany from both East and West called 'Pincers'. The
subsequent episode, 'Death Camps' deals with the attempted
extermination of the Jews. At this point, Isaacs allows himself one of the
few longer sentences in the entire document by reflecting:

> At this remove it must be possible to consider how these six million died.
> Stopping perhaps to wonder why the Jews allowed themselves to be herded
> into the gas chambers, and whether the Western allies could have hindered
> or prevented the process, we recount how the Germans did it.

This episode was finally titled 'Genocide'. Then follow an episode about
the war in Burma ('It's a Lovely Day Tomorrow') and one about the war
in the Pacific (in the series just 'Pacific').

The Treatment concludes with four episodes that from the
beginning Isaacs was absolutely clear he wanted to make.[50] 'Nemesis'
deals with the end of the war in Europe, the approach of armies from
East and West and Hitler's suicide in the Berlin bunker. Even in the first
Treatment its title was 'Nemesis'. Then follows an episode about the
decision to drop the atomic bomb and the end of the war against Japan
(in the series 'The Bomb'). Next is a programme called 'Reckoning'.
With the two great superpowers bestriding the world, and with Britain
exhausted, Isaacs asks 'Who lost? Who won?' This will become episode
25 and keeps its title, 'Reckoning'. Finally, Isaacs outlines an episode he
calls 'Requiem'. 'In the words of ordinary people and the songs they
sang, through painting and music' this episode will pay tribute to the
'great cataclysm' as an epilogue to the war. This became episode 26,
entitled 'Remember'.

This first Treatment produced by Isaacs during April 1971 is a
fascinating document. It clearly shows the influence of his discussions
with Frankland and of the list of military campaigns the series must
include. But it is without doubt the product of a single hand with a

single vision of how to construct the series. In his accompanying letter
to Frankland, Isaacs writes 'a very great deal is omitted, and not
only particular campaigns, but also some themes – The Neutrals,
Propaganda, Prisoners of War – for which I would have liked to find
room.' He explains that each episode has a theme but that the series as a
whole is chronological, with the viewer gaining an understanding, as
episode follows episode, of 'the overall development of the war'. That it
should be the product of someone who was not a history specialist is a
further sign not only of Isaacs's clear vision but also of how he was able
to listen to and absorb information from others. In the production of the
Cold War (1998) series nearly twenty-five years later, Isaacs gathered a
team of historians, producers and writers together who met for three
months to brainstorm the shape of the series. But, apart from
Frankland, Issacs had no team or researchers when he wrote *The World
at War* Treatment.[51] In the document, twenty of the final twenty-six
episodes are clearly recognisable, four are the clear foundation of what
would become final episodes, and only two would be dropped
altogether and replaced with other topics.

 The only copy of this Treatment to survive is the copy Isaacs
sent to Frankland, complete with the latter's handwritten comments.
This helps to give a clear indication of Frankland's thinking at this point
too. Frankland replies a few days later (his comments are undated in the
file) by picking Isaacs up on a few small historical inaccuracies – for
instance, in May 1940 the Germans did not go through the Maginot
Line but around it; Hitler postponed rather than cancelled the plan to
invade Britain in September 1940 and so on. Then he makes a few
suggestions of a more interpretative nature, like the need to bring air
power into the Battle of the Atlantic; that the episode on the bombing
offensive must deal with that of the French railway system before D-Day
and that of oil production sites in Germany, both of which 'had a
decisive effect upon the outcome of the war'. However, broadly
speaking, Frankland felt the Treatment was 'too much European
oriented' and that there was not enough on the war against Japan in
Asia. Frankland then makes three points which Isaacs absolutely takes

41

The Second World War.

WORLD WAR TWO

An outline of twenty-six hour long programmes.

(1) HOW? WHY?

Germany, bitter at defeat in the '14-18 war, and at the settlement of
Versailles, rises under Adolf Hitler and seeks territory. Britain
and France are unwilling to concert their deterrent strength with Soviet
Russia and abandon Czechoslovakia at Munich. The Nazis make a pact
with the Soviets, and the Western democracies commit themselves to alliance
with Poland. Hitler invades, and we are at war. *Reg to Japan~?*

Prague
order

(2) FIRST MOVES

The Nazi blitzkrieg sweeps the Polish Army aside, bombs Warsaw into
submission, and partitions Poland with the Russians. Nothing happens
on the Western front. Russia invades Finland. An abortive British
expedition to Norway helps bring down Chamberlain and, as the Germans
invade the Low Countries, Winston Churchill becomes Prime Minister.

(3) FRANCE FALLS

The German armies go round the Maginot line, and through it. The French
army and French society crumbles into defeat. The British Expeditionary
Force is cut off but, astonishingly as we shall see, rescued. Paris falls.
Petain sues. Hitler triumphs, and is poised to invade England.

(4) FINEST HOUR

Britain fights on alone, inspired by Winston Churchill. The BEF is
rescued at Dunkirk. The RAF wins, just, the Battle of Britain. Hitler
cancels plans to invade. A breathing space has been gained.

postpones

Britain begins to hit back: Desert war &
Bomber Command

42

The first page of the initial Treatment with Noble Frankland's comments in
pencil

up and which become guiding principles as the series unfolds. They all relate to taking a less Eurocentric or Anglocentric perspective. Frankland points out that 'The civilians who really suffered were not the Londoners or the people of Coventry.' They were in reality German civilians who endured the bombing campaign against them, the Russians 'through siege and occupation' and the Japanese through conventional bombing and the dropping of the atom bomb. Second, Frankland points out that the land operations 'which really exhausted the German army were not in Africa, Italy or France but in Russia'. Finally, Frankland tells Isaacs that the key to the success of Anglo-American operations was air superiority in the West and maritime air superiority in the Pacific; this meant 'strategic bombing' in Europe and the strength of the aircraft carrier force in the Pacific. Frankland would continue to argue against an overtly British perspective on the war throughout the production process and his comments, fell on receptive ears. Isaacs wanted his series to have a global perspective and feature the experience of other peoples whom many British viewers in the 70s would have known little about. Frankland sums up his response by saying that, despite his comments, he feels the 'thematic treatment of the subject is basically sound and is probably the best way of dealing with the problem [of what to include and what to leave out]'.

43

It is clear from this early stage that the series Isaacs wanted to make was not the story of Britain at war, although that would have been an easy call for ITV and probably of considerable appeal to an ITV audience. But he wanted to go beyond this with a far more ambitious project that would represent a real attempt to tell the story of the *world* at war. Frankland was 100 per cent behind this and throughout the next three years continued to remind and to cajole producers and writers to take a more global, less Anglo-American perspective on events. Frankland and Isaacs would make a good partnership.

The next document produced by Isaacs became the final working Treatment that, with minor modifications, was the principal guide for the making of the series. This document was sent to Frankland on 21 May 1971. It is titled 'A treatment for a television history in

26 parts.'[52] In responding to Frankland's comments about the lack of coverage of the war in the Far East, Isaacs has replaced the episode on Hitler's generals with one about Japan at war, 'a portrait of the least understood of combatants'. This episode would include Japanese attitudes to their enemies, to their prisoners of war and a look at why they fought so resolutely. It would simply be called 'Japan'. Isaacs agreed with Frankland's points about emphasising the suffering of the civilians of Germany, Russia and Japan, about the importance of the land battles on the Eastern Front and the role of air and naval superiority. In his handwritten accompanying letter he wrote 'I believe there is ample scope within my second draft for all these points to be made, though they will only become explicit at the commentary stage.' Isaacs noted and accepted all Frankland's factual corrections. Even so, the final document is close to the original Treatment and written in the same terse bullet-point style. Isaacs concluded to Frankland:

> If I have committed further gaucheries please let me know. But this draft, I believe, should serve as a basic structure and unless you have serious reservations will probably form the guidelines I shall be discussing with individual producers.

It is signed Jeremy Isaacs, May 1971. Unlike television proposals and Treatments of more recent times there is no protection of the document beyond the word 'Confidential' on the cover nor any attempt to mark it as Thames Television copyright – a sign no doubt of a more innocent time than today.

Frankland replied to Isaacs with a short letter acknowledging the document as the Treatment which would now be used to guide producers, writers and researchers in their work. He writes:

> I think you have met the observations which I sent you on the earlier draft both adequately and skilfully. Naturally the result is less than a comprehensive coverage of World War II but in my view it does provide a well balanced framework upon which the series could be based.[53]

While the production Treatment was being thrashed out, Thames put its relationship with Frankland on a proper footing by issuing a contract of engagement to him as an adviser. Thames's determination to avoid the problems Frankland had experienced with Tony Essex and the BBC on *The Great War* is evident in a clause stating that 'In regard to all filmed material which we propose using in the series you will assist us to ensure that only authentic historical material is used.' It confirmed that Frankland would receive four payments of £500 every six months starting on 30 June 1971 and ending on 31 December 1972 when the series was due to be finishing up.[54]

At the same time, Thames also began to negotiate terms with the Imperial War Museum for access to its material. Frankland made it clear that, as he was entering into a personal relationship with Thames, he should not also be negotiating terms on behalf of the museum. This he left to his deputy, Dr Christopher Roads. Roads was a man of immense energy and enthusiasm. During the 70s he negotiated the acquisition of HMS *Belfast*, the cruiser that from 1971 was moored on the Thames and became a permanent floating exhibit for the IWM. In addition he helped to acquire Duxford, the World War I and II airfield in Cambridgeshire that from 1976 became an outstation of the IWM. It went on to house the largest permanent display of fighting aircraft in Britain. Roads approached the negotiations with Thames Television with verve and relish. The general feeling was that the museum had been done over by the BBC in the making of *The Great War*. Roads was determined that this would not happen again and he was very aware that he was now negotiating with a commercial company that had a surplus of cash.

Roads negotiated with Thames like a Hollywood agent dealing with a major studio. On 11 May, a meeting was held at the museum between Isaacs and some of the Thames business-affairs people, and Roads and his colleagues. Frankland was also in attendance but Roads led for the museum. It was agreed that Thames could have access to all parts of the IWM's many collections.[55] Isaacs asked the IWM to allow access to all its material free of all royalty charges 'as it had in the past to

45

other companies' i.e. to the BBC for *The Great War* and to Rediffusion for *The Life and Times of Lord Mountbatten*. In return, Thames would make a generous contribution to the museum's Trust Fund and would provide combined colour prints of all the episodes for the museum to run in its cinema. In addition, Isaacs wanted access to a team of top specialists at the museum to advise the production team on specific issues over the next two years.

After Isaacs had outlined the Thames proposal, it was the turn of Roads to put the museum's case. First, he wanted to establish what credit the museum would receive. He wanted a separate credit to appear alone on the screen. It was agreed that Thames 'would accord the Museum a separate screen credit on each episode of the film, and would associate the Museum with Thames in all our publicity for the series'.[56] Then Roads explained that the 'scale of other charges the Museum might wish to impose would depend on the publicity value that might be expected to accrue to the Museum from the series' and on the fullness of the co-operation with Thames. The men from ITV realised he was going to strike a hard bargain. Roads wanted to know what contribution Thames would like to make to the Trust Fund. The figure of £5,000 (in 2012 approximately equal to £60,000) was mooted but Isaacs made it clear that this would have to be approved by the Thames senior management. Then Roads pulled a new hat out of his bag. He asked that Thames 'pay into the Museum's funds a small percentage of what the company might earn from overseas sales of the Second World War series'. This astonished Isaacs and the business-affairs people from Thames, who had clearly not been expecting such a request. Isaacs explained that he thought it would be very difficult to persuade the Thames Board of Directors to agree to this but that he would pass the request on.

Most of the rest of the meeting went through detailed points. At the time, the museum's film department had only one Steenbeck film viewing machine for public use and this would have to be shared between Thames and all other museum users. Isaacs offered to hire in and pay for two additional Steenbecks which would be made available

to Thames exclusively. This was left open. There was a discussion about the German newsreel archive film held at the museum. It was explained that under the 1952 Enemy Property Act this was regarded as war booty and therefore no charge would be made for its use in the UK but that this law did not apply overseas. Thames would have to negotiate a payment to Transit Films in Munich, an agency of the German government created to earn revenues from material generated during the Third Reich. The Thames team said they would be 'honoured' to hold a preview of the series in the IWM cinema (the Queen had attended the preview of the Mountbatten series). In a generous and unique gesture, Isaacs also offered to donate all copies that had been made of film material held at the IWM back to the museum's film department to help in its preservation of the film collection.

Two weeks later, the same group met again, this time without Frankland and with Roads once again leading the museum's negotiating team. Thames had asked for 'unrestricted access' to the museum's collection. Mindful that television people might demand sudden and urgent access to material, Roads insisted that this could only be accommodated within normal working hours. If Thames required any additional support outside working hours it would have to pay for staff overtime. This was agreed. Roads then returned to the matter of the credit, which he wanted not only to be separate from others but to feature at the start of each programme. This was a step too far for Isaacs. On factual programmes, credits are usually put together at the very last stage of the production process. Isaacs simply hadn't planned this far ahead and had no idea what other contractual issues would arise later, for instance with regard to a narrator. He concluded by agreeing that 'the IWM should have a separate credit, that it should be distinct from any credit to our sources, and from any other collaborators that we may have acquired'. He wrote 'I was and am reluctant to commit myself at this stage as to precisely where such a credit should be transmitted.'[57] It was agreed to leave this to resolve in good faith later.

The discussion then returned to the issue of the museum receiving a percentage of overseas sales. Isaacs and his team said that

they agreed to make a donation to the museum's Trust Fund of £5,000 and to make colour prints of every episode available to the museum (this was valued at a further £5,000). However, Isaacs reported that the Board of Thames had in this instance and as a positive sign of their desire to work closely with the IWM agreed to offer the museum a share of 5 per cent of the net profits of the series. This was then, and remains today, an extraordinary offer. It was extremely unusual for broadcasters to share the profits of overseas sales with any other party. And 5 per cent was a respectable percentage, and would be so today. In the letter summarising the meeting, Isaacs wrote deprecatingly 'This may, of course, not add up to very much.'[58] It was, however, without doubt a generous offer by Thames and would have big consequences later, as we shall see.

Roads was clearly pleased with the 5 per cent offer but now there was no stopping him. He asked that the museum receive not only duplicates of its own film that had been copied by Thames but also duplicates of film copied from other archives. Knowing that Thames would be unlikely to need such material in the future, Isaacs agreed. He then went even further and offered to deposit at the museum copies of all outtakes of the interviews shot during the production period. This was, again, a very generous offer. It was highly unusual for broadcasters to deposit their own specially shot material with others. Isaacs knew that the interviews they would shoot would have a real historical value and this fine gesture meant these would be available for posterity.[59]

Roads had led a very successful negotiation on behalf of the IWM and it is not surprising that Frankland wrote to Isaacs a few days later that the situation 'looks very satisfactory to me and I see no reason why a formal agreement should not be rapidly concluded'.[60] During the course of June, drafts of the Agreement went back and forth between Norman Mustoe, Head of Contracts at Thames, and the IWM. Jonathan Chadwick, the museum secretary and effectively its legal officer, made various corrections that were all agreed amicably. Thames would have to clear not only German footage with Transit Film but also all foreign-owned footage with the relevant rights holders. Thames had asked, as

48

broadcasters so often do in a rather lazy way, for 'exclusive rights' to the use of the museum's collections. It was politely pointed out that, as a public organisation, the museum could not offer 'exclusive rights' to material in its collection to anyone. This was subsequently changed to 'unfettered rights'.

Drafts of the Agreement were nearing completion when, at the end of July, Chadwick insisted that the deal should be run past the Treasury Solicitor. As the government's legal adviser, the Treasury Solicitor was similar to a company lawyer as far as the IWM was concerned. They had a reputation for being slow and pedantic. Roads was reluctant to bring them in as he thought everything would slow to a halt but he finally wrote on 28 July to the Treasury Solicitor's office. He received a prompt reply on 2 August suggesting a few legalistic corrections, for instance that the phrase 'unrestricted access' should be changed to 'reasonable access'. However, the Treasury Solicitor went on to point out that the 5 per cent offer should be followed up with a request by the IWM to have the right to audit the relevant Thames accounts to ensure it was receiving its fair return.

This began a debate within the museum hierarchy. Roads felt that asking for the right to audit the broadcaster's accounts would undermine the goodwill that had been created with Thames. Chadwick took a different view and argued that unless the deal was right, legal action could ensue at a future date. He noted, correctly, that it was 'normal business practice' for one party to request to see the accounts of a second party who was due to pay out funds. He wrote 'Thames TV is after all a business firm primarily and we must expect them to behave like one.'[61] This offended Roads, who felt he had built up a good relationship with Isaacs and did not want to alienate Thames at this late stage. Chadwick pressed Roads to write back to the Treasury Solicitor, which he did on 9 August, saying that asking to inspect Thames's accounts

would represent a serious departure from the level of trust which we hope is being mutually demonstrated in this agreement. We feel we have achieved

49

a pretty satisfactory settlement to have gained 5% and I would be inclined
to accept that they are a body of such standing that – as with one's
publishers – one would accept their word.[62]

This was rather surprising as Thames was still a new company and ITV
companies were not widely respected for their business affairs. Indeed,
the Treasury Solicitor did not agree and pointed out that, without access
to Thames's accounts, 'you might find yourself being presented with a
derisory sum each year and [with] no means of challenging it'.[63] But
Roads had made up his mind. He added a handwritten note to the letter
from the Treasury Solicitor stating 'I have decided not to include a
clause requiring the production of the accounts as this seemed to me to
be making this arrangement excessively severe and represented a
complete lack of mutual trust.'[64] He told Mustoe at Thames that the
museum was happy with the deal and on 17 August the final Agreement
between Thames and the IWM was signed. It was four pages long with
twelve clauses and incorporated all the main points in the deal. It did not
include Thames's offer to contribute £5,000 to the museum's Trust Fund
as Frankland felt this was additional to the core issues. Isaacs had been
generous in the dealings with the IWM but it took nearly six months for
Thames to make its payment to the Trust Fund. It was, after all, as
Chadwick had pointed out, a commercial operation and should be
expected to behave like one. Delaying payments until the last moment
was then, and is still, a standard business practice.

Now the working Treatment had been thrashed out and
agreed, and the core agreements were in place, it was time to recruit and
brief the production team and get on with making the series. But first,
Isaacs formulated his vision of how he wanted the series to work as
popular television.

7 Format

Although the Treatment written by Jeremy Isaacs in May 1971 says nothing about the format the series will adopt, he already had a particular stylistic approach clear in his mind, the key elements of which came out of his previous experience in current affairs. When he had edited *This Week* at Rediffusion and *Panorama* at the BBC in the mid-60s he had wanted to get cameras out of the studios and into people's homes, factories, schools and so on. This period coincided with the advent of 16mm film technology making cameras lighter and more mobile. People no longer had to come into studios to express their views as cameras could go to them wherever they lived or worked. Furthermore, editorially, Isaacs preferred to hear the voices of those directly affected by events rather than the views of experts or commentators. So one of his first guiding principles on *The World at War* was that he 'wanted to avoid punditry'.[65] The series would not feature historians, experts or pundits but would go instead for interviews with eye-witnesses and those directly involved in the events they described. There was only one exception to this in the three-year production period, in episode 25, which we will come to later.

As editor of *This Week* and *Panorama*, Isaacs had always valued the voice of the ordinary person caught up in events ahead of the views of politicians or leaders. A woman talking about bringing up a family in Liverpool with her husband on the dole and the rent collector at the door had more impact than the Minister of Housing explaining the intricacies of housing policy. Isaacs believed very much in the

eloquence of the common man or woman. This, again, was something of its time and a reflection of how the new technology of film was allowing film-makers to get out into the community. Drama producers were enjoying the same opportunities afforded by the technology and a new type of television drama was appearing at the same time, classed as the 'realist' school.[66] Isaacs wanted *The World at War* not only to escape from an Anglocentric view of the world and to represent the global experience of living through the war, but he also wanted to hear from ordinary Britons, Germans, Americans, Russians and Japanese caught up in the drama of war. This inevitably had its limitations because in the early 70s many generals, admirals, air marshals and politicians from the war, along with those who had been close to them, were still alive, and directors of different episodes were keen to interview these 'top people' and include their take on events as well. But Isaacs, without doubt, was more interested in the views of the victims and the victors of the war, the soldiers and civilians, than in those of the generals and politicians. Often they had written their accounts of events or had been interviewed before. The voice of the common soldier, let alone the German, British or Russian housewife, had not yet been heard.

52

Isaacs also liked the format of the BBC's *The Great War* and of Phillip Whitehead's *The Day before Yesterday*, a six-part history of British politics from 1945 to 1959, which had been produced at Thames in 1970 under his supervision. Isaacs felt that the combination of news footage of an individual or an event followed by comments from the individual in the footage or from someone who had been present at the event had a tremendous dynamic to it and was a 'marvellous format'. It would be the style adopted throughout *The World at War* and would play a central role in the impact of the series.

Isaacs felt strongly that as current-affairs producers he and his teams naturally had a duty to 'tell the truth' as far as this was ever possible, or at least not to mislead, nor to use information incorrectly. He believed that all testimony needed to be corroborated and so interviewees could not get away with telling lies or half-truths if this

could be demonstrated to be the case. And the visuals including all the film footage had to be as authentic as possible. He disliked the idea of reconstructions, which he considered 'fake'. In discussions with Frankland, who had been outraged by the misuse of archive film in *The Great War*, he decided to make this a key element in the production of *The World at War*. Of course, there was far more authentic film available from World War II than I but this would still be a major issue and Isaacs appointed Jerry Kuehl as an associate producer with the job of 'vetting the authenticity of the film evidence'. The series would become known for its authentic use of archive film.

Also, in current affairs it was standard for the reporter to write the links and comments. On *The World at War* Isaacs brought that tradition into documentary production by appointing writers to work with many of the directors. This is where a level of interpretation would come into each programme. In current affairs the reporters wrote the words. On *The World at War* it would be the writer who would provide the overarching narrative of each episode, always after Frankland had approved it for historical accuracy, and with the ultimate approval of Isaacs himself as editor-in-chief. Isaacs thought the directors 'had enough to do' with getting the structure right and sorting out the pictures, without having to write the narration. There are different traditions in documentary production. Some directors consider themselves, very much 'picture' people and are happy to leave commentary writing to others. Other directors take full responsibility and want to write the commentary themselves, seeing the script as an integral part of the final work. Isaacs felt that by keeping a level of control over the commentary writing and by engaging separate writers for the task, he would ensure a consistency of style across all twenty-six episodes unlikely to exist if each director wrote his own script. Again, this goes back to his current-affairs background where it is usual for the editor to work through the script with the reporter in the final stages of production.

Isaacs wrote of his experience as an editor on current affairs that the role

as I saw it, was to decide what the programme would do, and then after others had done the hard work, to fuss and nag over every frame and every syllable to ensure that what we broadcast was accurate, fair, clear, intelligible and as compelling as it could be.

He explained this further by writing 'I was not myself a film-maker. I worked with those who were. They travelled the world. I, mostly, stayed behind my desk. It was on the run-in to transmission that I could effectively make an impact …'.[67] But this inevitably brought Isaacs into conflict with some of the directors who wanted to write their own scripts, as we shall see.

The World at War would be, unashamedly, narrative history. Isaacs has argued many times that Television History is narrative history – that television is good at narrative rather than analysis.[68] This however, does not imply that Isaacs or others in the production team had a naïve view that history was simply a set of facts that needed to be put together in the right order. It was clear to many of them that history was itself a process of *interpreting* events from the past and placing them in some sort of understandable sequence. What Isaacs means is that he did not want The World at War to be a programme debating different interpretations of the war. Just as he did not want a team of historical advisers who would themselves argue and come up with different interpretations of, say, Allied strategy on the prosecution of the war, neither did he want to present viewers with several different interpretations of an event and leave them to make their own decision as to its meaning. This Isaacs did not believe was the function of history as presented on television.

There are several instances of how this approach is used very effectively in The World at War. A good example of deciding on an interpretation and sticking to it comes in the episode 'Alone', directed by David Elstein. Elstein had taken a Double First in History at Gonville and Caius College, Cambridge and joined the BBC in 1964 as a junior trainee. He had worked on Panorama under Isaacs and, although still young, was one of those to leave the BBC after Isaacs's departure and

Jeremy Isaacs in 1973, his vision shaped the series from start to finish

later join him at Thames in 1968. At this point in his career Elstein could
have returned to academic history (he wrote several articles in *Purnell's
History of the Second World War*, a popular encyclopaedia-style part
work on the war that came out at this time); he could have stayed in
current affairs where he was clearly on the way up (he went on to
become editor of *This Week* after *The World at War*); or he could have
gone into documentary production. He directed two episodes of *The
Day before Yesterday* for Isaacs and Whitehead, and was an obvious
choice for Isaacs as a director on *The World at War*. As a historian, he
had written about Britain during the summer and autumn of 1940 so
Isaacs asked him to make the episode 'Alone'. One of the issues in
this programme was why the Germans had shifted the focus of their
bombing offensive against Britain in early September 1940 from
bombing RAF airfields to bombing civilian centres like London. It was a
decision that allowed the RAF to survive and ultimately led to German
failure to win the Battle of Britain. The main theory as to the reason for

this change of tactics was that RAF bombers had bombed Berlin at the end of August 1940 and Hitler, in a fury, had told Goering to order his Luftwaffe to bomb London in retaliation. Elstein did not think this was a likely explanation, considering it more probable that the Luftwaffe believed that the RAF bases had already been put out of action and that they would either have a clear run in bombing London or would provoke the remaining RAF fighters to come out to defend the capital where they could be destroyed in the sky. The film made no attempt to offer any alternative interpretation. Having decided on a version of events, this was the single account the programme provided. Elstein later wrote that this was 'poor history' but ' "good" television narrative'.[69]

The episode 'Inside the Reich' delivers another outstanding example of how narrative storytelling can work on several levels. This programme asks the question: what did Germans know about what was happening to the Jews? There are clearly many different answers to this question and the programme allows four individuals to speak and answer at length. Hertha Beese (captioned as a Berlin housewife) begins the sequence by explaining in German that she took in and sheltered Jewish refugees. The following three interviewees all then speak in English. Christabel Bielenberg tells an extraordinary story about agreeing to provide a short-term refuge for a Jewish couple in her cellar, despite being warned by a neighbour that she and her entire family faced being deported to an extermination camp if discovered. The Jewish couple only stay two nights and then they depart, leaving her cellar neat and tidy with no sign of their brief stay. Bielenberg discovers later that they were arrested at a railway station and sent to Auschwitz. Bielenberg's body language as she relates this story is remarkable. Even thirty years after the event, she is disturbed when recalling these events; and in her pained delivery she wrings her hands (which the camera picks up in close-up) and never looks directly at the offscreen interviewer. She concludes her account by saying 'This is the most painful and terrible story for me to have to tell because after they left I realised Hitler had turned me into a murderer.' She quickly looks up at the interviewer and then down again into the agony of memory.

Christabel Bielenberg giving her agonised testimony in 'Inside the Reich' –
'Hitler had turned me into a murderer'

The third piece is from Albert Speer, who demonstrates no such remorse. He tells of how a Gauleiter came to him one day and told him that dreadful things were going on in concentration camps in Upper Silesia in Poland. Speer reflects that he should have gone to Hitler and asked what was going on but did nothing. This to a degree made him complicit too. 'Not doing it [i.e. speaking up], I think nowadays was the biggest fault in my life.' The viewer is left wondering not only if Speer means what he says but how many others in the senior echelons of the Nazi Party also did nothing to find out and potentially stop what was going on.

The fourth interview is from Emmi Bonhoeffer, also captioned as a Berlin housewife. We are not told that she was part of a leading church family known for its opposition to Hitler. She decides one day that she can no longer remain silent about her knowledge of the atrocities being committed and she tells her friends as they queue in line for a local shop that the Nazis are not just deporting the Jews but killing them and even making soap out of their corpses. 'I know that', she says forcefully. The other housewives in the queue argue with her, denying that this is true and accuse her of listening to enemy radio broadcasts whose only purpose is to discredit Germany. They warn her that she will end up in a concentration camp for repeating such lies. That evening she tells her husband what happened and he considers her 'idiotic' for saying such things in public. He tells her 'Please understand that a dictatorship is like a snake. If you put your foot on its tail it will just bite you. You have to strike the head.' This ends the sequence and is a neat segue into the story of the July Bomb Plot and the attempt to assassinate Hitler.

The four statements add up to a remarkable piece of television. They are long, the whole sequence running for six minutes forty-six seconds. For the researcher, Sue McConachy, to have got the German women to speak so revealingly and honestly is a fine achievement in itself. The director, Phillip Whitehead, is brave to run an uninterrupted sequence of interviews (the only cutaway is a still photograph of Bielenberg's house) for this length of time. But as a historical record of what Germans knew or said or of how they responded to the presence of

Jewish refugees, it is fascinating and deeply revealing. There is Bielenberg's angst thirty years on; Speer's expressed but not convincing remorse for having done nothing; and Bonhoeffer's determination not to remain silent but to speak out. It is narrative television but it most certainly is not superficial or simplistic in its interpretation of how Germans responded to the situation of the Jews during the war.

Having said this, how does *The World at War* sit in the broad canvas of the presentation of history on television in Britain? Many critics condemn Television History for being simplistic, for not allowing any variation to its own godlike historical narrative, for doing little more than building a nationalistic consensus and a national memory prioritising certain groups and classes and marginalising others. Television History has also been criticised for its fakery, pretence and gross simplification.[70] Nevertheless, for millions of people who would never think of buying or reading a history book, it remains the primary means by which they derive their understanding of the past. This clearly applies to *The World at War*. There will be millions of viewers whose principal knowledge of World War II comes from the TV series. It is certainly the case that *The World at War* is narrative history and as such provides only a single interpretation of any one event, even though this can be layered, as in the episode 'Inside the Reich'. But it is possible to watch the first episode, 'The New Germany', and not be aware that a debate had raged for years between historians about the causes of the war. Or to watch 'The Bomb' and not be aware of the intense controversy about the decision to drop the atom bomb. But there is nothing about *The World at War* that plays on the usual myths about Britain with its back to the wall displaying the Dunkirk spirit and so on, the repeated refrain of right-wing politicians. When Churchill was appointed Prime Minister in May 1940, he was seen at the time not as a saviour but as a dangerous adventurer, as is made clear in 'Alone'. The presentation of the Holocaust in 'Genocide' was the first time the mechanics of extermination had been explained on British television.

Television History is precisely what it says it is, history made to work on *television*. This is quite different to written history. Each

59

episode contains only about 1,500 words of commentary. This is roughly equivalent to a ten-minute lecture. Any historian would find it difficult to summarise the road to war in 1939, in ten minutes. So, of course, *The World at War* leaves much out, as Jeremy Isaacs was only too aware would be the case when he started out. But all history involves a rigorous process of selection. And claims that the series was 'definitive' came not from the programme makers themselves but from the Thames Press Department or from press reviewers.[71] Television is a linear, sequential medium. One sequence immediately follows another without pause or much time for reflection. But good television can still make the viewer *think* as well as make him or her *feel* the potent impact of visuals combined with words and music. *The World at War* did not attempt to create a national consensus about the war. It offered a set of diverse and mixed explanations about a conflict that cost 55 million lives. An American ex-serviceman in his 50s told Jerry Kuehl, after a screening of an episode of *The World at War*, that he now realised how his job as a stoker on an American troopship in the South Pacific helped to shorten the war, and thus save Dutch Jews from the extermination camps. Kuehl was amazed that the man had never read anything about the history of World War II that would have given him this insight before. But that, of course, is entirely the point, as Kuehl realised.[72] This man did not want to read history books but had enjoyed, appreciated and made his own connections from watching a popular television series. That is its strength. And that is the core of its appeal forty years later.

8 The Team

In late March 1971, Peter Batty was on holiday in Switzerland with his family when Tesler and Isaacs phoned to say that the World War II series was now on and they wanted him to work on it. After his return, on 16 April, he met with Isaacs, who wanted to get on with production as soon as possible. Batty was offered a contract as freelance producer-director for a two-year period starting on 1 May 1971. The fee was £20,000 (approx £250,000 in 2012). When Batty began work there was still no Treatment as Isaacs was finalising this in consultation with Noble Frankland. Finally, on 21 May, the working Treatment was finished and sent out, and three days later Batty met with Isaacs to discuss it. It was agreed that Batty would produce what would become a sort of pilot for the series, 'France Falls'. Isaacs did not want to make the first couple of episodes to be transmitted at this stage. He wanted to leave the first episodes the public would see until later in the production period when everyone, himself included, was confident of the format.[73] 'France Falls' was episode 3 in the transmission order. Batty agreed with Isaacs the style that the series would follow. And Isaacs agreed that Batty's knowledge and experience qualified him to write his own programme commentaries and he did not need to work with a writer.

Batty spent much of June viewing archive film at the Imperial War Museum, and also at Visnews and Movietone. He met some potential interviewees in early July and on 19 July 1971 filmed the first 'takes' for the series. This was location footage at the Meuse river and in the Ardennes, where Rommel had broken through the French lines in

May 1940. One of Thames's most experienced film cameramen, Mike Fash, shot the footage with Sandy MacRae as sound recordist.[74] The team then went on to film the first interviews. Batty interviewed General André Beaufre, who had been *aide-de-camp* to General Georges of the French High Command in 1940 in Paris; then he interviewed General Walter Warlimont, a German staff officer in 1940, and Field Marshal Hasso von Manteuffel, a panzer commander, in Munich. Isaacs was delighted that production on the series was at last underway.

The final team that would work on *The World at War* amounted to about fifty people. Production of the main series went on for a three-year period. And the Specials that were produced afterwards took another year. At the beginning, Isaacs recruited the key figures who would work on the project continuously for the next four years. Liz Sutherland had been a production secretary at Granada in the early days in Manchester, joining the company in July 1958. Later, as a production assistant, she had worked with Isaacs at Granada on *What the Papers Say*. She had a reputation for super-efficiency and Isaacs was 'bowled over by her ability to work hard'.[75] She moved to London and worked at ABC and then at Thames in its early days in 1968 before leaving to go freelance.[76] In April 1971, after a chance meeting with Isaacs at the NFT, she was offered the vital job of unit manager on what was still called 'The Second World War Project'. She began on 17 May and remembers that 'none of us really had any idea how to make a series on this scale'.[77] Part of Sutherland's job was to see that the production kept broadly to the budget but she was astonished to find, on arriving at Thames, that no inflation factor had been built in (inflation was then running at 20 per cent p.a.) and that the Contingency had been removed from the budget to keep it down to £440,000, a figure thought to be acceptable to the Thames board. As time unfolded, however, she remembers that 'no one really talked about the budget'. Once the series was underway, it would be very difficult to halt it.

Film research for a series of this sort was going to be at the core of the operation. John Rowe had been the film researcher at

John Rowe as film researcher visited film libraries around the world and had a reputation for never giving up until he had found what he wanted

Rediffusion on *The Life and Times of Lord Mountbatten*. He had built up a reputation as a researcher who would never take 'no' for an answer and would keep hunting for film until he had found what he wanted or until every avenue had been exhausted. When he transferred from Rediffusion to Thames he became a 'one-man film research department' finding and buying in footage for everything from *This Week* to children's programmes.[78] In April 1971, Isaacs asked him if he would like to work on a long series about World War II. Rowe, naturally, jumped at the chance. In May, not only did he start to look for the archive film but he also began to put the systems in place for copying it and working on it at Thames. He also did bulk deals with the principal commercial library and newsreel sources in the UK, offering them substantial guaranteed upfront payments of between £4–£6,000 in return for access to a large amount of material at well below the rate card.[79] Rowe was to work not only with the main London film libraries but also, over the next three years, in the Netherlands, Australia, Japan and at the National Archives in Washington.

In the autumn, Raye Farr joined Rowe as the other principal film researcher on the series. An American who had studied German and initially joined *All Our Yesterdays* at Granada in 1966 to translate

63

Raye Farr as film researcher found extraordinary new archive footage in Koblenz and Washington

German newsreel scripts, Farr worked on the series for four years before leaving to travel to India with her boyfriend, feeling she had 'had her fill of war'. Brian Inglis recommended her to Jeremy Isaacs who called her after her return and persuaded her to join the team. It was his vision that the series was to be 'more about people than about battles' that convinced her, initially against her better judgment, to work on another war series.[80] For three years Farr scoured the film archives of the world, concentrating on the film collections at the Imperial War Museum in London and the Bundesarchiv in Koblenz. She was to come across some extraordinary finds as the series progressed. At the peak of production

Alan Afriat as
supervising film
editor worked
out the complex
technical processes
for *The World at
War*

65

Michael Fox, an assistant editor on the series, also joined Rowe and Farr
as an additional film researcher.

The other key person from the start of the series was Alan Afriat,
who was appointed supervising film editor. Afriat had started at
Rediffusion as a film trainee in 1959 and had soon begun editing current-
affairs programmes like *This Week*. He transferred to Thames in 1968,
working with the distinguished documentary film-maker Richard Broad on
some of his early ecology films like *And on the Eighth Day* (1969). Afriat
had worked with Rowe on the big *Mountbatten* series and had learnt a lot
about the problems of copying archive film from different sources around
the world. As two 'staffers' who were on *The World at War* from the
beginning, Afriat and Rowe now created a system that would cope with
copying tens of hours of film on different formats from around the world.

The end product of *The World at War* was to be a 16mm colour print with a combined audio track. Although two-inch videotape was well established as a broadcast medium by the early 70s, there were many different video formats including PAL (the UK system), NTSC (the US system) and SECAM (used in parts of Europe and elsewhere). Also, some broadcasters were beginning to adopt the newer one-inch video format. Conversion from one video format to another was still complex and involved a substantial degradation of quality. 16mm film was, however, a universal medium and could be up-converted easily and at high quality by every broadcast station to its own video format for transmission, or could be transmitted directly from film through a telecine machine. From the start Thames had seen *The World at War* as a project with considerable international sales potential and so it was decided to make the master version of each programme a 16mm colour print. But Rowe and Afriat had found on the *Mountbatten* series that copying black-and-white material on to colour film stock could entail all sorts of tonal problems, giving sections of the black-and-white film a bluish, yellowish or greenish tint. They also knew that film material would be copied from film archives around the world on to many different film formats – some would be 35mm negative originals copied on to 35mm finegrain interpositives; other master material would be 35mm finegrains then copied on to 16mm negatives; other master material might originally be on 16mm. Faced with these challenges, the two men devised a process of duplicating everything that was originally on black and white after it had been edited on to a colour reversal internegative (CRI). This created the additional problem that all the material copied from archives would be on the wrong film geometry and so had to be copied on to an A-winding 16mm negative rather than the usual B-winding neg or all the images would be flopped over by the duplicating process. This involved taking all the archive film through an additional generation of copying, but extensive testing at the film laboratory, Humphries, showed that this made little difference and was more than made up for by the even tonal quality of the black-and-white material.

On 10 June 1971, Afriat wrote a six-page note outlining the system they planned to follow in copying archive film and in producing the final 16mm colour print. The method they decided to adopt was good for final image quality and had the advantage of reducing the master film material from 35mm to 16mm at an earlier stage than was usual in the making of television compilation films. 'I probably saved Thames hundreds of thousands of pounds' Afriat reflected later.[81] However, the drawback was that it was a complex process that took time and Isaacs remembers the 'endless, frustrating delays in waiting for material to come back from the laboratories'.[82] Also, mastering on to 16mm colour film meant that quite basic processes had to be done as an 'optical' – this was the process of making a duplicate negative through a special machine at the laboratories. Herbert Maiden, in charge of the Optical Department of Humphries, worked long and hard on *The World at War* over the next three years. But even the name captions identifying each interviewee, which could easily have been electronically added on to a video version of a programme, had to go through an optical duplicating process as the master was on film. This involved duplicating the original colour film through the optical printer and overlaying a separate film with the name caption on it. There was a colour degradation almost every time this was done. That is why even on a lot of more recent DVDs of the series that have been digitally remastered, there is a level of colour degradation every time a name caption appears. For instance, the face of John Colville, Churchill's private secretary and an important interviewee in the series, goes a delicate shade of green every time his name caption comes up.

In order to cope with the vast quantity of film that John Rowe and Raye Farr would soon start copying from film archives around the world, an assembly cutting room was opened to service the production. The film researchers were to log the basic details of every story copied and on arrival it was logged on a new 6″ × 4″ card system devised by Rowe and Afriat, carrying technical details of the original source material, whether it had been cleaned at the labs, what programme it related to and a brief description of its content. Every piece of copied film was given a new story number and was numbered along the edge of

PROGRAMME NO	G/T	M/M	F/G	SYNC / MUTE	DATE	STORY NO.
SUBJECT:				SOURCE:		LENGTH:
				REF:		ORIG FORMAT:
				DATE ORDERED:		
				HENDERSONS TREATMENT:	YES/NO	
				DATE TO LABS:		

A card used to log archive film for *The World at War*

the frame so it could be identified within the Thames system. The system was designed so that the four editors in each cutting-room working simultaneously (five at the peak of production) would be able to access every frame of film needed for making their own programme quickly and painlessly. Jenny Holt was the principal assembly editor at the centre of the cutting-room operation from the summer of 1971. Roger Chinery was in charge of liaison with the laboratories to try to ensure a smooth flow of material into the system. Thames publicity later said that the researchers had viewed more than 3.5 million feet (approximately 750 hours) of archive film. From this mountain of material they selected stories that were copied and brought back to London. In addition, there were 368 interviews amounting to approximately 300 hours of specially shot footage and interview material.[83] All of this passed through the new system that had been specially created for *The World at War*. It would be a gargantuan challenge. But in the pre-computer era, the team successfully coped with thousands of card indexes and endless paper logs.

On 6 September 1971, Afriat began editing the first film that would go through the production process, 'France Falls' with Peter Batty. Batty left Afriat to get on with editing the material around the structure he had given him and then began work on his second film, 'Barbarossa'. Five weeks later, on 8 October, Batty viewed the first cut with Jeremy Isaacs. Isaacs felt there was far too much commentary, too many generals and not enough soldiers in the programme. The editing of 'France Falls' continued.

Michael Darlow was the second director to join the production in the summer of 1971. Darlow began his career as an actor but while performing in the West End in the early 60s he had started to make his own 16mm documentary films, influenced by the Free Cinema movement. John Boorman invited Darlow to work with him at the BBC in Bristol. But Darlow was not cut out for the world of the BBC and resigned when a documentary project fell through and he was asked to direct a game show instead. In 1964 he joined Granada as a trainee director working on episodes of *All Our Yesterdays*, on the local news and on *Coronation Street* as he was keen to direct actors as well as documentary. In 1967 he went to Russia to make a film for Granada to mark the fiftieth anniversary of the Russian Revolution called *Ten Days That Shook the World*. While in Russia he was shocked to discover the scale of the civilian suffering during the long siege of Leningrad and suggested an idea that became *Cities at War* (1968), a trilogy of films Darlow produced about London, Leningrad and Berlin during World War II. In each film, the stories of the civilians took centre stage. The series won a Society of Film and Television Arts (SFTA) Award (the predecessor to the BAFTAs) in 1969.

69

Darlow made a documentary about Johnny Cash in San Quentin Prison which he asked Martin Smith to edit. But he and Smith resigned when the Granada management asked for changes to a sequence about a prisoner on death row. Jeremy Isaacs invited Darlow to come to Thames to make a drama documentary about Charles Dickens and then asked him to join *The World at War*. He directed the second episode into production, 'Occupation', about life in Nazi-occupied Europe, before

going on to direct one of the central and most important episodes in the series, 'Genocide' (see Chapter 12).

Another key person brought into the production at an early stage was Jerry Kuehl. Kuehl, an American who had been interested in the history of newsreel and documentary film from his student days, had come to Britain as a postgraduate student at St Anthony's College, Oxford. While at Oxford he had known Jeremy Isaacs although they did not keep in regular contact over the following years. Kuehl had worked on the fringes of the BBC's *The Great War* series as a research assistant for Corelli Barnett and subsequently worked in Paris for the NBC European Production Unit. In early 1972, Isaacs asked Kuehl to come and have a look at the first four rough cuts to be completed. Kuehl wrote a critical note about the four programmes, pointing out problems with the music and the commentary but most of all with the misuse of the archive film. 'I'm afraid that it sounds rather sour and carping', wrote Kuehl. 'I'm sorry about that but I thought it would be more helpful to be critical, rather than make a lot of flattering remarks.'[84] Isaacs asked Kuehl to join the production team and he played a variety of roles over the next few years, but more than anything he acted as the 'conscience' of the team, as a sort of internal quality-control officer, constantly arguing from within about the incorrect use of archive footage and generally providing a critique of working methods and of historical facts and details.[85] Some of the team were infuriated by his regular criticism and ignored it. Others used a memo from Jerry Kuehl as an opportunity to take another look at a sequence or to try to improve a part of the programme that they knew was not quite right.

The first two researchers[86] to join the production team were Isobel Hinshelwood and Sue McConachy. Hinshelwood had read Geography at Edinburgh University, went to Border Television to work on educational programming, then to ABC and from there to Thames. She was a meticulous organiser who started by looking for still photographs for the series and went on to find interviewees, especially American veterans. McConachy had read Modern Languages at Bristol University and had worked at the BBC from 1965 to 1969 and then for

Jerry Kuehl, who double-checked the use of archive film and acted as quality-control officer

71

ZDF, German television, in Munich. The search for strong interviewees went on continuously from the summer of 1971 to the early months of 1974. In theory, there were millions of potential interviewees to choose from. Everyone over the age of forty at the time had some experience of the war. But the researchers were looking for individuals with particular testimony about specific incidents or moments that would feature in the programmes. And they wanted people who were articulate and clear about their own specific memory, not people spouting the bland and oft-repeated post-war accepted view of events. Although there had been many programmes about the war before, the researchers felt they were doing something different as this series was not about grand strategy and great commanders, it was about housewives and ordinary soldiers.

And they wanted to tell both sides of the story, 'the bomber and the bombed, the Nazi and the Jew'.[87] However, the researchers would find themselves grappling with various moral dilemmas as the production progressed.

Hinshelwood's research in the United States worked through veterans' organisations and found most people were eager to talk about their wartime experiences. The problem here was one of selection. Sue McConachy, as a German speaker, spent most of her time in Germany where people were reluctant to talk about the war. The challenge here was in persuading individuals to talk. McConachy found that when Germans did describe their experiences there was a freshness about what they said, as few had openly discussed their memories with family or friends, unlike in Britain or America. German veterans from the North African desert campaign were more willing to talk than others. This had been a relatively 'clean' conflict. Veterans from the Eastern Front were happy to talk about the cold, the frostbite and the harsh conditions. But McConachy found many unwilling to talk about what they had seen and done as soldiers or that they painted an overly rosy picture of what was known to have been a brutal campaign. Several veterans were not interviewed on camera because it was thought they would not give an accurate portrayal of how the German Army had behaved in Russia.[88]

When it came to interviewees who had known or been around Hitler, McConachy eventually found five people who had been present in the Berlin bunker with Hitler in April 1945 at the end of the war. Three of these, including Hitler's chauffeur, his adjutant and one of the soldiers who had burnt Hitler's body, were willing to meet and supply information but did not want to be interviewed on camera. The fourth, Heinz Linge, Hitler's butler, had spoken before and was willing to tell his story on camera. He described in vivid detail how he found Hitler's dead body, slumped on a settee, after he had shot himself, with the body of Eva Braun whom he had just married lying alongside. She had bitten on a cyanide capsule. Linge's gripping testimony appears in 'Nemesis', episode 21.

With the help of a friend, McConachy succeeded in tracking
down Traudl Junge, Hitler's secretary, who had worked for him for
some years and who had taken down dictation of his last will and
testament in the bunker. She had no wish to appear on television but was
happy to meet with McConachy and tell her story. McConachy pursued
Traudl Junge for a year, building up a friendship. Finally, McConachy
persuaded Junge to appear on camera and her extraordinary interview
also appears in 'Nemesis'. McConachy later wrote that she suffered
pangs of conscience about persuading Traudl Junge to break her post-
war silence and to appear in the series, a decision that would inevitably
change her life. McConachy knew she was exploiting the trust she had
built up but also realised that Traudl Junge had made her own decision
to go public in this way. It was when pestered by the Thames Publicity
Department for photos of Hitler's former secretary on the grounds that

Traudl Junge about to be interviewed with Liz Sutherland, speaking, in the background

'She's such good box office' that McConachy wondered if she had been right to pursue Junge after all.[89] However, McConachy had no such qualms when it came to tracking down ex-SS officers who had participated in or witnessed the mass killings of the Holocaust (see Chapter 12).

Someone who felt 'soiled' by interviewing a leading Nazi was Martin Smith, who carried out an interview with Albert Speer. Speer had been Hitler's architect in the 30s and became a close friend of the German leader. During the war, Hitler had appointed him as Minister of Armaments and Speer had been extraordinarily successful in keeping the Nazi war machine not only running but in making it even more efficient than it had been previously. At the Nuremberg Trials Speer had pleaded guilty to committing war crimes and partly because of his plea had not been sentenced to death but to twenty years' imprisonment. Now out of prison, he agreed to an interview with Thames. Smith remembers arriving at Speer's grand mansion in Heidelberg where there was a large

garden running down to the Rhine. There were children playing in the garden. Smith disliked the whole experience of meeting Speer, and especially abhorred shaking his hand, which he knew he had to do in order to carry out the interview. To Smith, Speer appeared to feel no shame or guilt for what he had done and displayed no contrition for his role as a leading figure in one of the most evil regimes of the twentieth century. Smith felt disgusted at having to meet Speer and be polite to him in order to get him to talk on camera. He felt 'a fraud' for 'being nice to a shitbag'.[90] He stills feels bad and uncomfortable about the whole experience.

In 1970, Thames Television moved from the offices it had inherited from Rediffusion in Kingsway, to a large modern building on the Euston Road almost opposite Warren Street tube station. The building belonged to British Electric Traction, one of Thames's shareholders, and was offered to the new company on a favourable rent. Howard Thomas, Brian Tesler and Jeremy Isaacs, along with the rest of the company's senior management, were based at Euston Road. Also in this central London building were the studios for the daily show *Today*, the offices and cutting rooms for *This Week* and most of the Documentary Department. However, the building could not accommodate a series the size of *The World at War*, there was simply not enough additional space. So the production was based at the other site owned by Thames at Teddington Lock to the southwest of London. The Teddington base had once been the site of film studios before being owned by ABC Television, which passed the studios on to Thames when the company lost its franchise. It was a splendid site right on the river, from where the company produced most of its drama and light entertainment, series like *Opportunity Knocks* (1956–90) and *Bless This House* (1971–6) and, of course, *The Benny Hill Show* (1969–89). This was where *The World at War* team would be based for three years. At the back of the studio a set of huts opened out on to the car park. The huts were fitted out with benches and editing equipment and a whole set of offices was created alongside. It was in these simple and rather primitive conditions that the production and editing of every episode of

The World at War took place. Although Isaacs was based at Euston Road, from which he ran his empire of daily show, weekly current-affairs slots and one-off documentaries, he enjoyed travelling down to Teddington and working there. He described it as 'bliss' to get away from the pressures of the Euston office and for one or sometimes two days a week to concentrate totally on the production of the history series, in the later stages spending the whole day going from cutting room to cutting room, viewing cuts and working on scripts with the directors and writers.[91]

The members of the production team for *The World at War* were frequently away travelling. When they returned they found themselves in an isolated outpost of the Features Department mixing with other Thames staff from drama and comedy and with actors who were there to work in the studios. Sue McConachy remembered coming back from meeting ex-SS officers to mingle with this strange world of Benny Hill and Tommy Cooper. The canteen catered for all the production staff and one lunchtime McConachy recalled being joined at a table by a man wearing bizarre jousting gear. He explained he was there to appear in a medieval sketch in *The Benny Hill Show*. He politely asked what she was working on. 'I'm working on the Second World War', McConachy answered. 'Oh that's nice,' the man replied. 'Who's playing Hitler?'[92]

9 Music and Words

Title sequences say a lot about the programmes they introduce. The title sequence for *The World at War* is probably one of the most famous ever produced for factual television. Its combination of faces, flames, darkness, the block letters of the words of the title and the memorable, inspiring music of Carl Davis is masterful. It would give the series an identity and an epic, haunting feel from the start. Jeremy Isaacs later said that he 'owed everything' to the Graphics Department at Thames that came up with the images for the titles sequence.[93] In the summer of 1971, Tony Bulley and John Stamp, two of the senior designers at Thames, started to work on ideas for the title sequence. They wanted a more contemporary version of the powerful title sequence of the BBC's *The Great War*. They explored several visual metaphors, including one in which the leaves of a tree dropped off, and another in which the image of a heavy bomber with the roar of its engines obliterated the delicate sound of a nightingale singing.[94] But Isaacs believed a set of faces at the heart of the titles would signify the human stories at the core of the series. When he had redesigned the titles for *Panorama* in 1965, Isaacs had cut a montage of faces to a theme from Rachmaninov. So he briefed one of the researchers, Isobel Hinshelwood, to find a series of photographs for the title sequence.

There had to be something universal about the faces chosen. It was essential not to ask who these people were or what nationality they were. And in line with the format of the series in telling the story from the perspective of ordinary soldiers and civilians, the faces were not to

be of Hitler, Churchill, Stalin or Roosevelt, let alone of Montgomery, Eisenhower or Zhukov. While they were hunting for the right faces for the heart of the titles, Bulley came up with the solid, bold font for *The World at War* logo. It was loosely based on the block lettering found in German war cemeteries. It would feature throughout the promotion and marketing of the series to help create a brand identity. Then, when Isaacs had selected the photographs of the faces, they began to experiment by combining them in various different ways. The eureka moment came when Isaacs saw a storyboard in which flames rose up from the bottom of the screen to engulf the faces. He knew this was the version to go with. But the graphics team still had to work out how to achieve the concept they had suggested by combining faces, flames and lettering.

Meanwhile, Isaacs needed a composer to come up with something powerful to accompany the titles. He would regularly ask colleagues for recommendations and while in the reception of the BFI offices he got into conversation with Jonathan Miller. Miller told him that Jack Gold had just been working with a composer called Carl Davis and thought he was wonderful. Isaacs, who had never met Davis, tracked him down and asked him to come in for a meeting. Davis was an American who had come to England in 1960 to concentrate on composing scores for film and television. During the 1960s he had built up a body of work for both the theatre, with productions like Alan Bennett's *Forty Years On*, and for television programmes like *Omnibus* (1967–2003) for the BBC. One of these *Omnibus* programmes directed by Jack Gold, about the writer A. E. Coppard, had won a Prix Italia award and Davis had gone on to write several scores for dramas directed by Gold. It was still rare for original music to be composed for documentaries.

When in the summer of 1971 Davis was called into Thames, Isaacs described to him what the series was about and explained that he needed a composer for both incidental music and the title sequence. His view was that the 'job of the composer of the titles was to tell the audience in terms of sound what the series is going to be like'.[95] The title music should create a universal mood without sounding in any way

Carl Davis composed the powerful musical themes for *The World at War*

British or American. He also explained that during the course of the series the incidental music would be written to picture. The tendency was for original music to be composed as a set of themes that the editor would then lay in and cut a sequence to. Isaacs rejected this because he wanted the composer to see a cut of a programme and to write music to the roughly edited picture. This was going to be a big ask as the composer would need to evoke a range of emotions, from tragedy and defeat, to defiance and triumph. The music should also convey the tone of the different nationalities featured in different programmes. This would range from American to Asian. The two men got on well and Isaacs felt that Davis had understood what he was looking for.

Davis resolved that music from Eastern Europe should be his inspiration, as this was where the suffering of the war had been worst. He had a natural liking for the mood changes and chord progressions in Eastern European music and was a particular fan of Czech music. He quickly sketched out a sample score for the titles, having seen none of the visuals. Isaacs didn't think it was right, felt it was not strong enough. He explained to Davis that the series dealt with the appalling suffering of war and the title music needed something big to convey this. Davis agreed and put the title music to one side. He then got down to work writing the incidental music for the first few episodes that were going through the cutting rooms. First was 'France Falls', which required some pastiche French music to accompany original French recordings. Second was the episode 'Occupation' and during a viewing of the cut of this programme the editor Alan Afriat played Davis a piece by the Czech composer Martinu, entitled *Lidice*. It was dedicated to the memory of the village that had been destroyed by the Germans as a reprisal for the assassination of SS deputy-chief Reinhard Heydrich. The sheer emotional weight of the composition made a deep impression on Davis who began to think 'in its spirit'.[96]

In early 1972, Isaacs and Davis returned to the titles music. The graphics sequence had not yet been filmed but Davis saw a storyboard with the concept of the anonymous faces burning through from one to another, the climax on the face of a young child. He had another go at writing the music and played it to Isaacs on a piano. They decided that this was it. They agreed that the feel of this music had to be large scale and required a full orchestra. On 28 March, at the CTS recording studios in west London, where all the music had been recorded for the early Bond films, the magisterial, haunting theme for *The World at War* was recorded. Thirty-five London-based musicians were hired for the session. Isaacs felt that the impact of the music was 'overwhelming' and that it was 'everything that I had hoped for ... conveying every sort of emotion including compassion and endurance'. Most importantly for Isaacs the music did not convey 'three cheers for us as we have won the war' but was far more

profound.[97] It remains one of the most identifiable pieces of television music to this day.

The principal theme also offered a series of variations which Davis composed to use with sequences in different episodes. He showed tremendous versatility here. For instance, the theme occurs many times during the episode 'Stalingrad', initially as an accompaniment to the triumphant advance of the German VIth Army. Later a variation of the same theme serves to reflect the tragedy that army suffers in collapse and defeat, playing over images of dishevelled men stumbling into captivity. During the episode 'Reckoning', the same theme is played on a balalaika over images of the Red Army resting and relaxing. With great skill, Davis could adapt this variation or other themes to sum up the mood required by Isaacs and his directors.

Once the title music was recorded to length, at precisely fifty-five seconds, Tony Bulley, John Stamp and Ian Kestle in the Graphics Department went ahead and shot graphics calculated to fit the music to the exact frame. The shooting of a title sequence like this in the pre-digital era was a complex process involving many different stages arrived at after much experimentation. A set of photo-gravure lead plates of about 40 × 30 cm were made up from the photographs of the faces. They were rolled in black ink so the image was clear. These metal plates were then filmed as they were burnt with a blow torch from behind and actually began to melt. The separate flame effect was created with a gas burner of the sort that powered a hot-air balloon. The flame was filmed at high speed to achieve smooth, flicker-free movement against a black background. A large metal plate was also made up and filmed rising into shot emblazoned with the logo of *The World at War*. All the filming was done on 35mm. These separate elements were then taken to a special effects company in west London called Caravel, famous for shooting some of the special effects in *Thunderbirds* (1965–6). The different 35mm elements were projected through a bi-pack system onto a prism and reshot on a rostrum camera combining the separate effects. All the mixes were done in the rostrum camera to make it look as though the flames were melting the faces. This was shot,

81

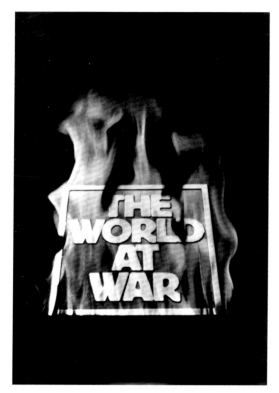

The World at War
graphics logo with
flame effect

82

like all animation in the 70s, frame by single frame, known as stop frame.[98]

Everything for the titles was done on film. Video effects were not used as the final master of the series had to be on film. The team was keen to establish a visual look to run throughout the series, to create a brand. So similar photo-gravure metal plates were made of the freeze frames at the end of each programme, over which the credits would roll in a similar form of lettering to that of the titles. Plates were also made of the freeze frames at the End of Part One – there was only a single commercial break in the original version of the series.[99] After a few weeks and what seemed like endless reshoots, everyone was happy with

the effect. The titles were complete. The finished sequence was copied to 16mm and was laid in with the music to the cuts of the first episodes that had been edited.

It was soon after this, in the summer of 1972, that Isaacs showed the fine cuts of the first two episodes, which still had the voices of the directors reading the commentaries, to Howard Thomas. Thomas was disappointed. He argued there should be fighting in each episode and thought both 'France Falls' and 'Occupation' were too downbeat and low key. Thomas believed a moment of maximum impact at the start of every show was necessary to keep an ITV audience. Nevertheless, Thomas showed the two cuts with Muir Sutherland, who was in charge of Thames's foreign-sales division, to Frank Packer, in London to buy programmes for his station, Channel 9 in Australia. They viewed the cuts after lunch at the Savoy Hotel. Packer was hugely impressed by what he saw and immediately made a big cash offer to buy the Australian rights to the whole series. It was the first time anyone outside Thames had seen anything of work in progress on the series. Packer's instant response was massively encouraging. In the way back to Thames by car, Thomas turned to Sutherland and said 'For heaven's sake don't tell Jeremy what they'll pay for it. He'll only want an increase in the budget.'[100]

From this early point onwards, it became clear to senior executives at Thames that they probably had an international hit on their hands. Already, a crucial decision had been made. In acquiring rights to the archive material to feature in the series, the team was told to buy out world rights, in perpetuity. The effect of this was roughly to double the cost of purchasing these rights. As buying the rights comprised a substantial part of the budget this added a major cost to production. No one today can recall who made this decision or where this requirement had originated. Liz Sutherland inherited this aspect of the budget when she joined the team. John Rowe had been told to go for a buyout of rights when he had started working on the series. The precedent for buying world rights had probably been set in making *The Life and Times of Lord Mountbatten*, which had an obvious

international appeal from the start. But it was a far from normal practice at the time as it was so costly and payment had to be made upfront. For instance, when the BBC bought the rights for *The Great War*, it had not acquired world rights and only held rights for a period of ten years. When the rights expired the series could no longer be distributed and it was a major task to reacquire all the rights nearly thirty years later in 2002. But Thames was a commercial company, keen to exploit its output overseas and so in many ways it was natural that it should see big projects like this as a source of future income. And in the first few years of the company's existence, the revenue from overseas sales had started to grow significantly. Critically, for Thames and all other ITV companies, revenues from overseas sales had never been subject to the Levy, meaning that every penny earned from sales went straight back into the bottom line. The ability of Thames and its successors to sell *The World at War* around the world and to continue to sell it 'in perpetuity' would underscore the long and successful shelf life of the series (see Chapter 14). No more important decision was ever made for the commercial success of the series than that to buy out in advance world rights in perpetuity in all the archive material.

With the international opportunities in mind for the series, a debate began during 1972 as to who should read the narration. Isaacs's first instinct was that this should be read by a reporter-type figure. He favoured someone like Robert Kee, of whom he was a great admirer. He began to think of assembling a team of perhaps four reporters of this ilk, each of whom would write and record the commentaries for six or seven episodes. Ludovic Kennedy and Derek Hart were other names thrown into the ring. Another was Rene Cutforth, who actually recorded commentaries for three episodes. Isaacs did not believe that an actor could read the commentaries convincingly enough and that it needed someone who could really understand them, preferably the person who had written them, to bring out their full sense. Moreover, Isaacs doubted his own ability to work with actors. Many years before, when making *What the Papers Say* at Granada, Sidney Bernstein had criticised him for not toning down the readings of the newspaper extracts by the actors,

whom Bernstein thought all tended to overact.[101] The fact is that a team of reporters narrating would have been extremely impractical and would have disrupted the cohesion of the series for viewers. For the first year or so, the issue could be parked. But by the summer of 1972, as more episodes were completed, a decision was needed as to who should narrate *The World at War*.

The international-sales people at Thames, led by Muir Sutherland, were in no doubt that an A-list actor 'name' must read the commentary. This would add enormously to the selling potential of what was still seen as a rather niche factual series. Also, they argued that, as Michael Redgrave had read the narration for *The Great War*, they must go one higher. The momentum began to build up that none other than Britain's greatest acting talent and star, Sir Laurence Olivier, should read the narration. Another issue then came to play the deciding factor. Thames still had to sell the series to the rest of the ITV network. Although the ITV Controllers were in favour of a World War II series, some thought the scale of it too big. They were being asked to accept twenty-six factual programmes in a primetime slot. Several of their own programmes would have to be dropped to make way for the Thames series. The other network companies, led by Granada, hinted that if Olivier narrated they would accept the series in primetime. David Plowright, the Director of Programmes at Granada, was the brother of Olivier's wife, Joan Plowright. He offered to make an introduction to Olivier on behalf of Thames.

Isaacs was still not happy with the choice. There were all sorts of reasons for *not* offering the job to Olivier. He was extremely busy with other commitments and was immersed in the process of handing over the directorship of the National Theatre, which he had run for ten years, to Peter Hall – a transition that he was not making easily. Also he was not well and was still recovering from treatment for cancer. He had never narrated a factual series before. And it was likely that he would be extremely expensive. Nevertheless, the overseas sales team representing the commercial wing of Thames was adamant that it had to be Olivier. And now Granada and the other ITV network companies seemed to be

favouring him. So Isaacs was sent off to meet the grand old man of British stage and screen.

Their first meeting took place in one of the temporary offices at the National Theatre behind the Old Vic. Isaacs was nervous and not sure how to proceed. But Olivier got there first and after welcoming him said 'We have a little commerce to discuss.' Isaacs felt that this put his pet project firmly in its place. Isaacs explained what they were doing and how long it would take. They would allow a full day for each recording and a few extra days for contingencies. Recordings would take place over the next eighteen months. Olivier thought he could find the time. Following the meeting, a deal was done with Laurence Evans, Olivier's agent. He was offered £38,000 as a buy-out fee for the whole series, approximately equivalent to £475,000 in 2012 money, or about £15,000 per day in 2012 terms.[102] Nice work.

The recordings were made in a small studio in Oxford Street and when the day came for the first commentary recording Isaacs admits to having been extremely nervous. He knew how to deal with reporters but he 'didn't want to argue with Britain's greatest actor'.[103] He was simply in awe of Olivier. The first episode recorded on 12 October 1972 was Peter Batty's 'France Falls'. A few days later they were to record 'Occupation'. Isaacs was there as were Batty and the film editors. They began by projecting the film for Olivier to see. Then he asked how they wanted him to do the recording. The programme makers explained that they wanted Olivier to hold back, that the real drama was in the film and in what the interviewees said. The narration was there to link the programme together. Then they began recording. Olivier went into a tiny booth and read out the script. At the end of the session, Isaacs was relieved and thanked Olivier before the actor left. As soon as he was gone Batty turned to Isaacs and said 'It's no good. He's a disaster. It is too quiet; his voice keeps fading away at the end of the line … . You'll have to get rid of him.'[104] In trying to hold back, Olivier had simply gone too far. And Isaacs had not intervened to correct him.

Isaacs spent an anxious few days before the next recording. He had no idea how to tell someone of Olivier's stature that his

performance was not right. He later wrote 'How does a current affairs producer, dealing for the first time in his life with a great actor, find words to tell him he isn't good enough?'[105] He decided to tell Olivier there was a problem and to play the recording back to him. They had got halfway through when Olivier interrupted them. 'I see what you mean.' he said. 'It's tired. I'm tired ... I'll do it again.' They recorded the whole commentary again and then recorded the commentary for 'Occupation'. Everyone agreed that this had gone well. Isaacs heaved an enormous sigh of relief.

A few days later, Isaacs received a call from Evans, the agent, asking him to come around immediately. In his office, Evans explained that Olivier was not happy and wanted to pull out of the project. He explained that Olivier had just finished filming the movie *Sleuth* (1972) on which a planned eight-week shoot had dragged on to sixteen weeks. He was also exhausted from performing evenings and matinees in Eugene O'Neill's *Long Day's Journey into Night* at the National. The actor was simply very tired. 'Have you tried telling him he is wonderful?' asked Evans. Isaacs was astonished: why on earth would a man like Olivier need a current-affairs producer to tell him he was doing his job well? 'Oh my dear boy', Evans said, 'of course he does.'[106] Isaacs learned the first lesson in dealing with 'luvvies' – always tell them how good they are at what they're doing. At the next recording, Isaacs had prepared some jokes and was far more relaxed with Olivier, who in response became far more cheerful about the whole business.

The recordings went on for weeks and months. The recording days scheduled around Olivier's packed timetable settled into a routine. Olivier would read the script for the first time on the train up from his home near Brighton. He was often late. Then, wearing his characteristic red braces, he would watch the programme first and discuss it with the team. Frequently, Olivier would claim they were wrong about something and that he knew more than they did about the war. After all he had lived through it. Each time the programme makers would argue back. With Batty, Olivier never tried to correct anything he had written. He thought Batty was too clever by half. Isaacs was present at every

Laurence Olivier at a commentary recording for *The World at War* complete with red braces

recording and would run the session. The director for each episode was also present if available, but by this point it was Isaacs's show not theirs. Liz Sutherland was present at every recording. She made sure that Olivier's favourite Malvern water, along with an apple and some cheddar cheese was always available when he wanted a break. Sometimes he would drink champagne. They began by recording to picture but after a while decided this was taking too long and recorded 'blind' to the stopwatch. Then the editors would lay in the commentary afterwards. Olivier was technically proficient but appeared tired and exhausted throughout the whole period. Eventually, he did relax more with what he clearly regarded as these strange factual programme makers around him. During one session, in March 1973, news came through that Noel Coward had died. Olivier had to break off to record a tribute to Coward for the BBC in a very sombre and formal style. Then

he spent the afternoon regaling the Thames team with increasingly outrageous stories about Noel Coward. The last recording was made in January 1974, three months after the series had started transmission.

The fact remains that Olivier provides a very mannered and unusual read on *The World at War*. He insisted on his own idiosyncratic pronunciations – 'Stalín' instead of 'Stahlin', 'Soviét' rather than 'Soviet'. In these and other words he simply gets it wrong and sounds eccentric. He should have been corrected but Isaacs was too much in awe of him. When it comes to reading passages of poetry as, for instance, Russian poetry in 'Red Star', or the Keith Douglas poem in 'Remember', Olivier is just right. He gives a tremendously powerful read without going over the top. But he was simply not suited to commentary reading. It requires a particular skill to read factual narration and not every actor has this skill. The style of narration in *The World at War* was clipped with short phrases, sometimes just a few words with no verb in a sentence. Sometimes the writing was almost terse, which did not suit Olivier's style of delivery. He found it difficult to play the backseat role needed for the best of factual narrations. Olivier was a physical performer who acted through his whole body. Isaacs heard many years later that the actor had not enjoyed doing the commentaries for the series. He apparently commented: 'You must understand I'm an actor and you're asking me not to act but to narrate. I'm not acting by just using my voice and there is no audience except this microphone in the booth.'[107] Listening to his delivery today, Olivier is one of the weakest links in *The World at War*.

However, this was not the view at the time. His name on the credits, appearing as it does at the start of every episode, gave an enormous boost to the whole project. The salespeople invoked his name relentlessly to sell the series, particularly in the US. Here, the agent working for Thames, Don Taffner, did not go through the networks but instead visited and sold the series to 150 smaller stations from coast to coast across the country. Much play was made there of the Olivier narration and many local American papers billed it as Olivier's series on World War II. In addition, on the ITV network and elsewhere around

89

the world, the association with Olivier lent the series an imprimatur and a status as something special, something unique on television. Isaacs in retrospect is absolutely certain that the series could not have been the success it was without Olivier's voice and that it was 'a huge plus' to have Olivier read the narration.[108] It's curious that something that comes across as one of the weaknesses of the series today was so vital to its original success.

The general critique of narration in historical documentaries is that it sounds like the voice of God to the viewer, speaking with total authority, as a 'guarantor of truth'.[109] Certainly in comparison to a presenter-led series when we are listening to the words of Kenneth Clark, Simon Schama or Niall Ferguson, authorship is more difficult to ascertain in a commentary-led programme. Whose words are we listening to? Whose view are we getting? In the case of *The World at War*, are these the words of the writer, the director or of Jeremy Isaacs? Of course, the answer is that it is a mix of all of them. The overall structure and approach came from Isaacs. The individual decisions about what to include and what to leave out in each episode came from the director. And the final turn of phrase, often carried out in very few words with 'artistic economy', is that of the writer – as Neal Ascherson, one of the most brilliant of the commentary writers freely admits.[110] But does the Olivier commentary sound like the voice of God, an all-knowing authority dispensing infomation which the viewer has only to sit back and take as gospel? I think not. It sounds like an actor giving a performance. The scripts are usually very strong and play up the human drama. But neither the narration nor the narrative is all-knowing as we have seen. It allows for interpretations, for different angles and for complexity. That is the strength of this series, if not of all Television History.

Isaacs summed up by saying that the two great contributions to *The World at War* were the music from Carl Davis and the narration read by Laurence Olivier. 'Their presence is there throughout the series', he explains and argues that they are the only elements common to every episode.[111] The music of Davis without doubt lends coherence to the

entire series. Even though additional music from the time is used, his original score provides stylistic cohesion. In one sense, Olivier's narration helps to do the same. But the very distinctiveness of his read, which helps bind the programmes together, also introduces a sense of theatricality, of listening to a performance, that is quite alien to the rest of the series and that can grate with the viewer today.

10 Production

By everyone's account, *The World at War* was an extremely happy production. It was a young production team, most were in their twenties and thirties and Isaacs only turned forty during production. People got on well with each other. Relationships began, affairs were conducted. Around the production, all the stages of normal life carried on. Babies were born and were brought in to sit in cutting rooms or offices. People got divorced. But within the team, everyone seems to have been close and genuinely excited by the work they were doing. Raye Farr describes it as an 'extraordinary creative experience' almost akin to the war itself, with a strong sense of 'comradeship, sacrifice, separation from loved ones and the emotional toll' of being immersed in the harrowing subject matter for a long period of time.[112] Most of all, the team was filled with a sense that the series was something special. Jeremy Isaacs was a producer who inspired his people to great work and who made everyone feel good about what they were doing.

Regular screenings of fine cuts of episodes were held at Teddington. This was very good for team morale. Some directors, like Martin Smith, liked these collective screenings a lot. It was a chance to see and discuss different programme makers' work with them. Jerry Kuehl seized the opportunity to point out mistakes in the use of archive film or errors of historical fact. Others, like Peter Batty, resented the criticism from junior members of the production team that came up at these screenings. After one of the first screenings on 9 March 1972 there was a general discussion in which a lot of criticisms were aired. The mix

of sound effects and music was thought to be wrong; the commentaries were criticised for being too wordy; there was too much to do and to check in the time available. Isaacs did not object to the open criticism but was concerned they were falling behind schedule. He sent a memo to all production personnel saying

> It was useful talking. We will talk more … [but] … . We are behind schedule. We must keep the pressure up. We must complete as quickly as possible. We must not fall further behind than we have. It will be a long war. But we are winning.[113]

New directors kept arriving as the team grew larger. Peter Batty with 'France Falls' and Michael Darlow with 'Occupation' got the series started. Next came David Elstein working first on 'Distant War' and then on 'Alone'. In early 1972, Isaacs made a bold decision to offer Martin Smith, the editor of Darlow's 'Occupation' episode, a directing job. Smith had left school at fifteen and had become a rewind boy in a cinema projection booth. He slowly worked his way up the projectionist ladder at ABC cinemas and constantly tried to break into television as an editor, only to find that all the jobs seemed to go to Oxbridge graduates. Eventually, in 1964, he made his break into the world of freelance editing work joining a Soho cutting-room company called David Naden Associates. Here he gained valuable experience working on television documentaries like *Disappearing World* (1970–93) and current affairs like *World in Action* (1963–99) for Granada. He edited the documentary about Johnny Cash in San Quentin Prison for Darlow who then brought him to Thames as his editor. Smith had only ever directed a short religious film for the BBC before being asked to step up by Isaacs. He started to work on 'Red Star', the film that would really put the Russian experience in the war on the map. It was the first full-length documentary Smith had ever directed and to this day he thinks it was extraordinary that Isaacs gave him this opportunity that completely transformed his career.[114] But Smith was not the first, nor would he be the last, director given new opportunities by Isaacs. Ben Shephard, who

94

Phillip Whitehead accepting an award for his work as a current-affairs producer – he combined work as an MP with directing episodes of *The World at War*

started on the series as a researcher, was also given a chance to direct an episode, 'Tough Old Gut'. Jerry Kuehl, who took over the episode on 'Stalingrad', was given the opportunity to direct the penultimate episode, 'Reckoning'.

Making up the rest of the directing team was Phillip Whitehead, an experienced ex-BBC current-affairs producer who had been editor of *This Week* at Thames from 1967–70 and had made *The Day before Yesterday* documentary series in 1970–1. Whitehead was unusual in that he combined his role as Labour MP for Derby North with that of television producer.[115] Later John Pett, another experienced director, joined the team and directed three episodes including two on the war in Asia and the Pacific, and 'Morning', the film about the D-Day landings. Ted Childs made two of the most difficult episodes to produce.

'Wolfpack' on the Battle of the Atlantic presented a challenge because of the lack of authentic archive film. 'Whirlwind', on the bombing offensive against Germany, was always going to come under the supremely critical eye of Noble Frankland as he had written the four-volume official history of the strategic bombing offensive and was, in addition, a veteran of that conflict. In fact, Childs got Frankland's agreement to his approach from the beginning and the historian was thoroughly pleased with the final film. Hugh Raggett completed the team of directors, putting his name to three episodes.

Isaacs gave every director a two- or three-page synopsis of what his programme was to cover, usually recommending a couple of books to read as well. These short synopses would then be digested and passed on to the rest of the team. Raye Farr, the film researcher, remembers receiving a list of twelve points that 'Inside the Reich' was to cover from her director, Phillip Whitehead, the MP, written on House of Commons notepaper. She went off to the Bundesarchiv in Koblenz to start looking for suitable footage and took a copy of William Shirer's *The Rise and Fall of the Third Reich* to read every evening in her spare time.[116]

All the directors spent much of their time away, filming. In May 1972 Batty went on tour across the world. He flew to Los Angeles, then on to Honolulu to recce Pearl Harbor and then on to Japan. At that time, due to a union agreement, Thames staff flew first class on flights of more than 1,000 miles and on the leg from Honolulu to Tokyo, Batty found himself the only person in first class. He had the whole of the upstairs dining room on the jumbo jet to himself. After a few days in Japan with the researcher Reginald Courtney Browne, cameraman Peter Lang and the film crew arrived from England. Batty conducted thirty-five Japanese interviews then flew with the crew back to Hawaii, then back to Los Angeles, then to the east coast, finally returning after nearly six weeks of travelling. Elstein also filmed in Japan. Darlow went to Israel and Poland and filmed with cameraman Frank Hodge at Auschwitz. In September Batty filmed in Egypt and was nearly arrested at El Alamein when the crew inadvertently filmed the HQ of the local Egyptian military intelligence unit.[117]

While the directors were away, the film editors kept everything going back at Teddington. Six editors worked across the series.[118] Alan Afriat, who had set up the cutting rooms and the technical systems, was the supervising film editor but spent his time focused on editing five episodes. He was joined by Peter Lee-Thompson who also edited five episodes, Jeff Harvey who edited six, Beryl Wilkins who edited six and David Taylor who edited three. Martin Smith joined the team as a freelance editor on 'Occupation' and then went on to direct two episodes. The time allocated for the editing of each programme was roughly three months: two months for the picture editing with the director, then a month for the sound editors to lay the tracks, for the music to be composed, the commentary recorded and the final audio to be mixed. But almost every programme was different and the first episodes took a little longer while, by the end, with transmission deadlines approaching and the adrenalin flowing and with everyone familiar with the process, the editing process had speeded up considerably.

Every edit began with the director and editor and, if they were available, the researchers viewing all the copied archive film along with all the interviews for that episode. It was rare for everything to be there at the start of the editing process. Usually the team was still waiting on the arrival of film from overseas archives and sometimes not all the interviewing had been completed. But at this viewing, the director marked up the transcripts of the interviews, indicating all the most pertinent sequences of sync interview. Every editor and director worked differently. Some directors provided a detailed edit script and left the editor to get on with it. Other directors just gave the editor a list of sequences with the marked up transcripts and would pop in every few days to see how things were developing. Some editors liked to work closely with their director. Most of *The World at War* editors were happy to be left on their own and, as the directors were away filming and setting up later episodes, that was often necessarily the case. There was usually a viewing after two to three weeks by the director and editor of an assembly of archive and interview material. These assemblies

might be as long as two or three hours, and decisions about major cuts and structural changes would be made at that point. A second viewing would follow, two or three weeks later, of something like a rough cut running at about seventy minutes. This would often be the first viewing attended by Jeremy Isaacs and also by the writer. The film was generally projected in a small theatre. The team would then move on to talk through the film over a Steenbeck viewing machine. There were typically still many gaps left in the cut at this point to be filled by graphics and archive film that had not yet arrived.

After decisions had been made about what to cut and, in some instances, what to add, the programme would be cut down to about three minutes over length. Then at about fifty-five minutes it would be viewed again. The final cuts would then be decided on and a fine cut of almost exact length, fifty-two minutes and thirty seconds, would be made. Almost everyone remembers the last cuts that had to be made, as with most programmes, as being the hardest. It was often this fine cut version that was shown to the team if there were a collective viewing and to Noble Frankland and others from the IWM. After a further viewing the writer would then head off with reams of notes and timings to work on the commentary script; the sound editors would start to lay the audio tracks; the graphic sequences would start to come through and be edited in; and Carl Davis would be asked to write new musical sequences. All of these processes would often involve further trims and alterations. When the script was finished and had been approved by Isaacs and Frankland, a guide commentary was recorded by Alan Hargreaves, a reporter on *This Week*, and it was this version that was shown to Olivier and to which his commentary was recorded. Finally all the sound tracks would be pre-mixed. Then, with the music and commentary recorded, Freddie Slade, the senior Thames dubbing mixer, would mix all the sound effects together. While this was taking place, Humphries the film laboratory would make any optical effects and would print the final 16mm transmission print.[119] Because so much of the creative production process lay on the shoulders of the film editors, Afriat asked that the editor should be given the first credit in the list of

Neal Ascherson's work on *The World at War* taught him much about the concision needed when writing television commentaries

end credits. Isaacs agreed to this, and accordingly the film editor gets top billing at the end of each episode.[120]

On most of the episodes an outside freelance writer was commissioned to hone the final script from the working commentary written by the director. Neal Ascherson wrote three episodes, 'Red Star' with Martin Smith, 'Inside the Reich' with Phillip Whitehead and the first episode to be transmitted but one of the later episodes to be made, 'The New Germany'. Ascherson was a journalist who had started at the *Manchester Guardian* in the 1950s and had been a foreign correspondent for the *Observer* based in Berlin from 1960 covering events in much of Eastern Europe. Returning to Britain in 1970, he had helped form the Free Communications Group, a lobby determined to

introduce a fairer social ownership of the press and television media. But when Isaacs asked him to work on *The World at War* he had never written a film commentary before. It was explained to him that the pictures always came first, with words only needed to provide links or information when there were no suitable visuals – and even then these words should be kept to an absolute minimum.

Ascherson embraced his task and rose to the challenge on his first episode, 'Red Star', in which he believed Martin Smith was telling the story of the mighty battles on the Eastern Front from the Russian perspective for the first time, as far as most Western audiences were concerned. Ascherson was enormously impressed with the craft skills of the researchers, film editors and directors he now observed for the first time, at what he calls 'the perfectionism of the British documentary tradition'. Overall, he felt he learned a great deal about the discipline of writing from working on *The World at War*. Journalists are inclined to be 'wordy' he feels, but working for television taught him 'how to convey something very intense in very, very few words'.[121] Other writers on the series came from different backgrounds. Angus Calder, who wrote 'Home Fires', was an academic. Stuart Hood, who wrote 'Nemesis', had been a television executive in the 1960s and was in the early 70s turning to academia. David Wheeler had been an editor of *Panorama* after Isaacs had left the BBC. But most of the others, like South African Charles Bloomberg, Charles Douglas Home, John Williams and Laurence Thompson were journalists. They all sat at a Steenbeck for hours or took away detailed timings and descriptions of scenes to refine the scripts.[122] They worked with the production team and with Jeremy Isaacs, writing, rewriting, sifting their prose and rewriting again, condensing the narration down to the final words of the commentary scripts.

99

The Thames team worked very closely with the staff of the Imperial War Museum. But inevitable tensions arose between the demands of production and the museum's need to preserve its material – the long-running conflict between the demand for access and the need for preservation. At a meeting on 22 September 1971, Clive Coultass, keeper

of the film department at the IWM, agreed that the Thames film researchers could have access to the museum's master materials, usually the original 35mm nitrate material, as this would provide the very best quality for duplicating. However, all of Thames's film processing was done at Humphries, a general laboratory with no specialist experience in handling old film. In July 1972 Humphries damaged some master material. Coultass, on behalf of the museum, was furious. Isaacs ordered an investigation into the circumstances, which found that the original nitrate film material had shrunk and jumped out of the processing machine at the lab. The museum would normally only have sent rare and worn material like this to a specialist laboratory used to dealing with such problems. There was a crisis in Thames's relation with the IWM. But it did not last for long. Thames needed the IWM and was paying well for access to the collection. And the museum staff knew that the IWM stood to gain a first-rate profile from its association with the series. Senior members of the museum's film department and other key IWM personnel were regularly invited to the screenings of fine cuts held at Teddington. Frequently, the specialist film researchers would discover new information about what was in the film that enabled the museum staff to improve the card index that at this time was the principal catalogue for the film collection. Anne Fleming, a senior member of the IWM film department, remembers the whole experience of working with *The World at War* as

> an extremely close working relationship and positive because so much information was shared. The team had worked extremely hard to use the film correctly and not just as wallpaper. It was especially rewarding because the programmes that emerged were excellent.[123]

Raye Farr reiterated this from the production side, remembering that she spent so long viewing footage in the IWM vaults at Hayes that it became 'a home away from home' and that the security people there had begun to think she must be a member of the IWM staff. Overall, Farr believed there was a 'deep partnership' with the museum.[124]

Noble Frankland, as principal historical adviser, continued to view episodes and provide comments and advice. He, too, found the experience a positive one, in marked contrast to his relationship with the BBC on *The Great War*. On this occasion he felt he was being listened to. Frankland's relationship with the production team was always channelled through Isaacs. Most of the production team had no direct contact with him at all and remember him as being very 'off stage' during the production.[125] All of Frankland's notes exist and it can be seen that he was particularly good at summarising the overall strategic picture at any one moment for the directors.[126] A typical comment would go something like 'At this point in the war, Monty's strategic imperatives were the following' and he would list them in two or three clear, crisp sentences. Television producers rarely receive such clear and focused guidance from their advisers. Either they hear nothing at all – a sure sign that the adviser has never had time to look at the programmes. Or they receive pages and pages of notes which they have to try to distil down into one or two sentences of commentary. Frankland got the balance just right.

101

There was only one real dispute with Frankland during the making of the series. On 18 October 1972 Frankland went to the Thames offices in Euston, as he regularly did, to view rough cuts of two episodes, 'Barbarossa' and 'Home Fires'. He dictated his notes to Liz Sutherland at Thames immediately after the viewing and sent them on to Isaacs. Of 'Barbarossa', directed by Peter Batty, he wrote 'I think this film is first class and I have very few comments.' However, he had a different reaction to 'Home Fires'. This was produced by Phillip Whitehead, the Labour MP. The writer of the episode was Angus Calder, also known for left-wing leanings and for his book *The People's War* (1972). Frankland objected to the treatment of Churchill in the film, seen mostly through the eyes of Labour opponents and through Lord Butler. Frankland wrote to Isaacs that

> This combination does him [Churchill] less than justice and might even give rise to the view that there is political prejudice in the film. The remedy

The only disagreement between Isaacs and Frankland in making the series was over the treatment of Churchill in 'Home Fires'

is to put in a little more of the Bulldog Churchill, especially in 1940, and a little less of the silly old senile warmonger.[127]

Isaacs wrote back to Frankland on 22 November:

> I think we disagree. If the programme were an account of Churchill the war leader, then I should agree with you completely. But the programme is not about Britain's war leadership. It is about social and political changes in wartime Britain. We have to explain to viewers how it was that in 1945 the British elector should have rejected Churchill's political leadership. So I think as a film *Home Fires* is fair. Even so I would not feel easy if the series as a whole failed to take account of Churchill's contribution to Britain's victory.

Isaacs went on to point out that the treatment of Churchill in the earlier episode 'Alone' about Britain in 1940–1 made for a fair and accurate balance across the series.[128]

A few days later, Frankland sent Isaacs a handwritten letter sustaining his objection. He agreed that the programmes should not 'stoop to hero worship' but argued that the question of balance was not only something to be maintained across the whole series but that 'Each programme should contain its own balance. Some people will only see some of the programmes.'[129] It was unusual for a television executive to be corrected on a point of political balance by a consultant, but Isaacs undertook to take another look at the programme to consider 'whether at this late stage there is anything I can do to meet your feeling that we have been unfair to Churchill in it. I will let you know what I decide.'[130] There is no further mention of this disagreement in the surviving correspondence. Neither man today can recall the dispute. And certainly the episode 'Home Fires' looks very much as Frankland describes it from the rough cut. So we can assume that Isaacs made his decision and came down on the side of his film-makers. He would listen to criticism and argument but over a matter like this, which was more of interpretation than of fact, he would decide. The editorial buck stopped on his desk.

A year into production, Thames decided to publish a book to accompany the series. But who should write it? Everyone on the production team was working flat out. John Hambley, the publicity manager at Thames, approached Paul Johnson. He wanted a journalist to write the book, not a historian, as he wanted it to be written based on the scripts, interviews and themes of the twenty-six episodes. Hambley wrote to Frankland to inform him. The latter was miffed and wrote 'This is the first I have heard of the proposal [to write a book] … . Please send me a note upon Mr Paul Johnson and especially on his previous writings.'[131] The negotiations dragged on and eventually collapsed. Mark Arnold-Forster, a journalist on the *Guardian*, was commissioned to write the book instead and produced a draft over the next few months. The book differs from the TV series in many ways. It is not chronological but is a military history that follows each of the main

103

theatres of battle from beginning to end of the war, an approach that
Isaacs had rejected at the start of production. It is based far more than
the series on the British official histories published from the 50s through
to the early 70s. As a consequence it is far more Western-oriented than
the TV series and about half of the book is devoted to the British
war effort.[132] In March 1973 it was sent to Frankland, who was not
impressed and declined the invitation to write a foreword. Isaacs later
thought that maybe he should have intervened and asked Frankland to
write the book.[133]

During production Isaacs decided to abandon one of the
programmes from the original treatment. The programme called 'Big
Three' was to have looked at the political direction of the war and at the
relationships between Churchill, Roosevelt and Stalin. 'Did Churchill
ever sway Roosevelt? Roosevelt trust Churchill? Either of them take
Stalin's measure?' asked Isaacs in the initial Treatment.[134] However, as
the Soviet Union was closed to the production for the foreseeable future,
Isaacs realised that archive film footage of Stalin would be limited to
what was available in the West. Furthermore, the production would
have no access to the people around Stalin who had known and advised
the Soviet leader. There were plenty of people available for interview
who had been close to Churchill and Roosevelt. But Isaacs thought this
would make for an unbalanced film and an unfair judgment of Stalin
and his war aims. So he ditched the programme altogether. Instead, after
discussions with Frankland, he decided to replace it with a film on the
Italian campaign, which the two men realised had been left out of the
original structure. Churchill had called Italy 'the soft underbelly of
Europe'. General Clark, who led the march up through Italy, had
responded by calling it a 'tough old gut'. 'Tough Old Gut' became the
name of the new episode on the Italian campaign and Ben Shephard,
who had joined the team as a researcher, was asked to direct it. It is a
mark of the strength of Isaacs's Treatment from May 1971 that 'Big
Three' was the only programme dropped during the entire production.

It was decided at an early stage to look for amateur footage, or
home movies, to supplement the more official feel of the newsreels, the

propaganda film and the military record footage. This came out of the idea that the series should be more about people than just battles. Adverts were put out in Britain, America, India, France and Germany asking for anyone with interesting personal film to contact the production team in London. The ads went into newspapers and magazines likely to be read by veterans, like *Gunner* magazine in the UK, and *Armed Forces Journal* in the US. Hundreds of people sent in clips of film they or their parents had taken. Most of it was of no historic interest. Jerry Kuehl viewed all the material and corresponded with the donors, generally to thank them and to explain that their film was not being used but if they were happy it would be donated to the Imperial War Museum. The IWM began to build up a valuable collection of wartime home movies. Some of the material sent in did prove to be valuable, like some amateur film shot on the Eastern Front by German soldiers and colour footage taken by the Hamburg fire chief during the fire storms generated by the July 1943 bombing raids.

However, the home-movie material most associated with *The World at War* did not come from this advertising campaign. Lutz Becker was a German film-maker and artist who was working at the Slade in the early 70s, on a register of wartime films set up by the British veteran film-maker Thorold Dickinson. Becker had noticed in photographs of Hitler and his entourage at his mountain retreat in the Bavarian Alps above Berchtesgaden that Hitler's mistress, Eva Braun, was sometimes holding a Siemens 16mm film camera. He wondered where this footage had gone. On a trip to the US, Becker happened to meet a veteran who had been in a raiding party at Hitler's Obersalzberg chalet in May 1945. This man remembered finding piles of film cans there that were handed over to the US Signal Corps. His interest thoroughly aroused, Becker began to hunt this footage down. It was not listed in the film collections at either the US National Archives or at the Library of Congress. At this point, Lutz Becker was taken on by David Puttnam and Sandy Lieberson, who had formed a company, Visual Programme Systems, to produce cinema documentaries. They wanted to make two films about the Nazis in the 1920s and 30s. With their backing, Becker made a

couple of trips to Washington to try to track the Eva Braun film material down. In a remarkable piece of detective work, Becker finally found a set of neglected 16mm film cans in a vault in Maryland. He opened the cans and looked at the first few frames of each 1000′ roll of film. He could see scenes of Hitler and the Nazi elite relaxing in the Führer's mountain hideaway. And all the footage was in colour. It was the archive film equivalent of discovering Tutankhamun's tomb. What he saw amazed him. He called Lieberson in London who authorised him to copy all the film immediately.[135]

Becker's extraordinary detective work was taking place while John Rowe and Raye Farr were researching archive film for *The World at War*. They soon got to hear about the discovery of the Eva Braun home movies. Naturally they became interested in the footage. Lieberson rushed ahead with production of the two cinema documentaries. They were both finished in 1972. The first, *Double Headed Eagle*, was directed by Lutz Becker. The second, *Swastika*, was directed by Philippe Mora and co-scripted by Becker using a lot of the Eva Braun home movies. When shown at the Cannes Film Festival in 1973 *Swastika* caused a stir because people felt the footage made Hitler and his friends look human rather than keeping up the myth that he was some sort of monster. *Swastika* can claim a 'first' in including the Eva Braun home movies, but it was only seen by small numbers within the then rarefied circuit of cinema documentary audiences. Farr obtained access to the material and it featured in some episodes of *The World at War*, notably in the first episode 'The New Germany' and 'Inside the Reich'. This was its first screening to a large television audience. It is difficult now to realise the impact created by the home movies of the Nazi elite at play. In the years since, the footage has been used extensively and has become some of the most recognisable stock shots of Hitler in colour. It shows the Nazi leaders as typical petit bourgeoisie enjoying time off and participating in all the normal social pleasures in a spectacular mountain location. Eva Braun beckons the camera to come nearer as Hitler talks to a friend. Hitler strokes his pet dog, Blondi. He jokes with the young children

The Eva Braun home movies: left: Braun calls the cameraman closer to film Hitler at his mountain retreat; right: Hitler and Albert Speer chatting

of his colleagues like some kind of jovial but slightly distant uncle. Hitler, Speer, Goebbels, Ribbentrop, Himmler and the others sit around a table drinking coffee and eating cakes. Smart young waiters come and go. Martin Bormann fusses around. And in the background upright SS guards in their black uniforms stand to attention. The making of *The World at War* coincided with the discovery of the Eva Braun home movies and brought them to a worldwide audience for the first time. The Eva Braun material helped to reinforce the sense that the series was revealing something new and completely different about the war.

107

In the early months of 1973, with one-half of the episodes complete or approaching completion, the ITV network chiefs settled on transmission dates. It would be shown across the ITV network on Wednesday evenings at 9.00pm in the primetime slot before *News at Ten* (1967–), starting at the end of October 1973. The fact that Laurence Olivier was reading the commentaries helped persuade the doubters on the network committee that a factual series on this scale would appeal to ITV viewers. Alongside this, Muir Sutherland sold the series to WOR-TV, also known as Channel 9, in New York. This was the first substantial American sale and like ITV, WOR-TV wanted to

transmit the series in the peak viewing season of the fall. They scheduled it ahead of ITV for a September 1973 air date. By the summer of 1973 Muir Sutherland and his US agent Don Taffner had sold the series to twenty American TV stations from Los Angeles to Miami and from Houston to Chicago. From coast to coast it was now given air dates starting in late September 1973.

Working on a long television series, there comes a point where the end never seems to be in sight. Work has gone on for a couple of years, which in television terms is extremely long. Several programmes have been completed but there are even more episodes yet to make. It seems like it will go on for the rest of your life. But now there was a date in the schedules, the production team had a goal to work to. There was no way they could miss the transmission slots. The end was now in sight. In what he called 'the bunker' in Teddington, Jerry Kuehl remembers it was now a case of 'KBS – Kick, Bollock and Scramble' to get the series completed in time.[136]

11 Content

The World at War set a new benchmark for Television History. But in saying it was better than anything that had gone before, it is necessary to dissect some programmes in detail to look at both its strengths and weaknesses. It would be repetitive to analyse all twenty-six episodes, so what follows is a detailed account of sequences from six episodes, each of which reflect different aspects of the final series.

Every episode begins with a pre-Title sequence known in television jargon as a 'Tease' or what used to be called a 'Hooker'. The purpose of this one-to-two-minute sequence is one of Entonement, to set the tone and mood for what will follow and it could take the form of a short story or an archive-led visual sequence. In more recent years, the Tease has evolved into more of a menu of what the programme will include or a statement of what it is about. This type of Tease, along with summaries at the end of each part that sum up its content and outline what is coming up next, is largely an import from American TV programming. The thinking is that viewers joining a programme at any point in its duration should be made to feel 'welcome' and eased in to the progress of the film. But this was not the style in the early 70s when the Tease was a mood setter rather than a specific outline of what will follow.

One of the most impactful Teases in *The World at War* is that for the first episode, 'The New Germany'. It features images of Oradour-sur-Glane, the town in central France where soldiers from the Waffen-SS Das Reich Division massacred all 642 inhabitants on 10 June 1944 as a reprisal for a Resistance attack. The French decided to leave the town in

ruins, exactly as it was on the day the SS murdered its people, as a memorial. Over atmospheric specially shot material photographed by Thames cameraman Mike Fash, with no music, just the sound of a distant wind blowing, Laurence Olivier reads the following lines, slowly and deliberately:

> Down this road on a summer day in 1944 the soldiers came. Nobody lives here now. They stayed only a few hours. When they had gone, a community which had lived for a thousand years was dead. This is Oradour-sur-Glane in France. The day the soldiers came, the people were gathered together. The men were taken to garages and barns. The women and children were led down this road and they were driven into this church. Here they heard the firing as their men were shot. Then, they were killed too. A few weeks later, many of those who had done the killing were themselves dead, in battle. They never rebuilt Oradour. Its ruins are a memorial. Its martyrdom stands for thousands upon thousand of other martyrdoms in Poland, in Russia, in Burma, in China, in a World at War.

Without a beat, there is a cut to the first frame of the Titles with the strong incoming chord of Carl Davis's dramatic musical theme. The whole sequence lasts ninety-five seconds. The Tease makes certain things very clear about what is to come not just in this episode but in the series as a whole. It will be about the story of ordinary people – like the men, women and children of Oradour. It will tell of dreadful events – like the massacre of innocent civilians. It will set up a close link to the past it describes – this is the actual village where this atrocity took place, still standing today. It will reveal the awesome destructiveness of war – 'a community which had lived for a thousand years' is destroyed in 'a few hours'. It will not be condemnatory – 'A few weeks later, many of those who had done the killing were themselves dead, in battle.' It will not be a story of winners and losers – there are no winners in war. It will certainly not pull its emotional punches. And it will be a global story – the massacre at Oradour 'stands for thousands upon thousand of other martyrdoms in Poland, in Russia, in Burma, in China'. Ironically, there

The opening image of episode 1 of *The World at War* – 'Down this road ... the soldiers came'

will be very little about Poland in the series and only one further mention of Chinese suffering. But more than anything, the Tease of episode 1 tells the viewer this series will be epic in tone and in scale. Sit back and watch, it says, this will be something very special.

A great deal of thought and expense went into this opening, the first pictures and words of the series. Once Jeremy Isaacs had visited the village of Oradour and selected it for this Tease, a helicopter was hired so that Fash could shoot aerial images of the village ruins as well as take shots from the ground. But the argument about making its impact as strong as possible went on right up to the last moment. Isaacs and Neal Ascherson, the writer of this episode, were still arguing up to the point at which the commentary was actually recorded. Ascherson had viewed the sequence sitting at the Steenbeck, the viewing table in the cutting room, condensing his commentary for hours, getting it as short and as crisp as possible for maximum effect. He wrote the opening

words very much with Olivier's voice in mind. But as they went into the commentary recording the first line read 'The German soldiers came down this road on a summer day in 1944.' Ascherson and Isaacs both thought the opening line could be better. Neither of them can remember now whose idea it was to do two things to this sentence. But, first, they decided to move the subject, the 'German soldiers', from the front to the end of the sentence. Second, and even more importantly, they decided to use simply the words 'the soldiers' rather than the 'German soldiers'. By removing this single word, the entire sequence achieves a universality that takes it above mere reporting of a single atrocity carried out by German troops and into the realm of the dreadful crimes that are committed by desperate men in war.

At the recording, Olivier read the paragraph well. But Isaacs thought he could read it better and reminded him that these were the first words of his that would be heard by viewers, the first words of twenty-six hours of television. Olivier asked for a break. He got up and walked about stretching his arms and exercising his mouth muscles. Then he went back into the tiny commentary booth and re-recorded the words. Apart from a rather over-emphatic reading of the French name 'Oradour-sur-Glane', it is Olivier at his best. His slow delivery is not dramatic in itself. But with the silent pictures followed by the music and graphics of the Titles it adds up to one of the most dramatic opening sequences ever produced for a series on British television.[137]

The rest of this first episode tells the story of the rise of the Nazi state from Hitler's appointment as Chancellor in 1933 and the gradual mobilisation of the German people, particularly its youth, for war. And it chronicles the growing anti-semitism in the Third Reich, enshrined in its laws. The choice of interviewees reveals how the series will be different from most series about war. Christabel Bielenberg and Emmi Bonhoeffer, captioned as housewives, talk of the drip-drip process through which anti-semitism began to pervade everyone's way of thinking. Other interviewees talk of the enthusiasm they felt for Hitler in the early days and a sense of new energy and vigour that was unleashed. Clearly this series would take the Nazi state seriously and not merely

condemn it without trying to understand its appeal. Although the programme covers a lot of history, there is no sense of galloping through the years. The commentary is intelligent and sparse. The programme is well paced with plenty of time for some of the archive film sequences to stand out. Although the episode showcases some of the familiar images of the Nazi state in the 1930s it also uses little-known imagery like the colour footage of a 1936 farmers' rally and, most strikingly, the Eva Braun home movies, also in colour. The directing credit for the first episode is given to Hugh Raggett, although most people on the team recognise that it was Jeremy Isaacs and Neal Ascherson who guided the programme through the cutting room with Alan Afriat as editor.[138] It is an impressive opener to the series and sets up the stall well for what will follow.

Peter Batty directed and wrote six episodes of *The World at War*, more than any other director. He was the only person working on the Thames team who could be called a military historian.[139] As a consequence, each of his programmes has a very clear strategic overview of the battles it describes. But Batty's films have their own tone and work differently to the other episodes. Although Batty bought in to the idea that the series should convey the experiences of ordinary men and women, soldiers and housewives at war, he was repeatedly tempted away from this by the fact that so many senior military figures from the war were still alive and willing to be interviewed. He found it difficult to resist including this material that tended to give a very 'top-down' view of battle. Episode 3, 'France Falls', the first programme into production about the German offensive against France and the Low Countries, contains interviews with generals from the both the French and German High Commands of 1940 and with Sir Edward Spears, Churchill's principal liaison with the French. Batty also liked to interview war correspondents of the time, whom he thought could provide a clear analysis of what people felt. In this programme and in later episodes he features Lawrence Durrell and Gordon Westerfield, both celebrated wartime journalists. Having said this, he tells the story of the French civilians caught up in the defeat with real empathy, capturing in particular their sense of helplessness as chaos

fell across the nation. But he fails to include any civilian interviewees. In episode 8, 'Desert', on the war in North Africa from 1940–3, the film is more than ten minutes in before there is a single British or German interviewee who is not a general. The campaigning is described by members of the High Command and those on the staff of the commanding officers. This programme also includes General Sir Richard O'Connor, who led the Western Desert Force in 1940–1, one of the many instances during the series where a commanding officer was still alive and available for interview.[140] O'Connor was captured in one of Rommel's early strikes in the desert and comments that it was 'a great shock … I never thought it would happen to me'.

As a military historian Batty delivers a very clear strategic analysis of how and why France was defeated so quickly and how the see-saw war in the desert went back and forth across North Africa. All his episodes engage maps very effectively to convey sometimes quite complex battle plans. And there is nothing po-faced or inaccessible about Batty's programmes. They are well paced and show off the skills of the editor (Alan Afriat in the case of both 'France Falls' and 'Desert'). Batty liked using contemporary music, sometimes with irony, sometimes for straight emotion. In 'France Falls' he produces a delightful sequence about the French Army's very modest attack known as the 'phoney offensive' in the Saar while the German Army was busy invading Poland, cut to the popular French song 'Boom' sung by Charles Trennet. 'Desert' features a moving sequence cut to the song 'Lili Marlene', a hit with both sides during the North African campaign. In 'Desert' he adopts a technique with interviewees that had proved very effective for another director, John Pett, in the programmes about the war in the Pacific. Both directors interviewed several soldiers, sailors or airmen whom we never see but hear talking, a sort of audio vox pop cut to archival images. In 'Pacific' this works to create a sense of a chorus of voices to move the story forwards. In 'Desert', Batty uses the same technique but it jolts the viewer more. We *see* the generals and field marshals in vision but we only *hear* the men they commanded. They become a sort of nameless troop who somehow don't seem to merit a

name caption. It comes across, unintentionally, as though interviewees have been divided between named officers and anonymous men, a two-tiered interview system. Noble Frankland liked Batty's programmes for the concise way they got across complex strategic imperatives. Jeremy Isaacs wanted the series to have certain common stylistic approaches and a common attitude towards the war. But he wanted his directors to speak with their own voices and he did not want every programme to be made in the same way. Overall Batty's programmes are different to the others but the series as a whole is richer for having this diverse mix.

Episode 9, 'Stalingrad' proved to be one of the more troubled episodes. In the 1970s it was not easy for broadcasters to access the Soviet Union. It was the midpoint of the Cold War and, although it was known generically as the era of détente with President Nixon's visits to both Beijing and Moscow and the signing of the Strategic Arms Limitation Talks, Britain was playing its own game of Cold War hardball. In September 1971, the British government expelled more than 100 diplomats from the Soviet Embassy in London, citing evidence that they were KGB spies. This was inevitably followed by a tit-for-tat expulsion of British diplomats from Moscow. Relations between Britain and the Soviet Union fell to a new low. Against this background, requests by Thames to send a film crew to Moscow to interview veterans from the Red Army went unanswered. Although it might have been possible to find German veterans from the battle it was thought that including interviewees from one side only would give the film an unbalanced feel. As a consequence, 'Stalingrad' is the only film in *The World at War* with no interviews at all.

The first version of the film was put together by Hugh Raggett and film editor Beryl Wilkins. When it was screened for the others there was a long silence. The archive film had been jumbled up so that scenes from the hot and dusty summer of 1942 were intercut with scenes from the freezing winter of later that year. Jerry Kuehl was appalled at both the confused storytelling and at the misuse of archive film.[141] He was asked by Isaacs to take over the editing with Wilkins and ended up being credited as writer on the episode although he largely supervised its

production from then on. The story of the long battle of Stalingrad is told clearly in the final film with the help of two sets of letters from a Soviet and a German soldier to provide the human insight. The German VIth Army begins to strangle the city of Stalingrad during the autumn of 1942 but the Red Army holds on until the Russian winter arrives. From November, von Paulus, the German commander, requests permission to withdraw but Hitler refuses. Then the Russians counterattack and surround the entire VIth Army. There is at this point one of the most memorable sequences in the series. Archive film shows the soldiers of two Russian armies joining up to complete their encirclement of the Germans. Russian soldiers embrace as they meet in the thick snow. The images have been used many times before and since as a record of this momentous military moment that made probable the final victory for the Soviet forces in the battle. But Kuehl realised from the camera positioning and the perfectly composed shots of men celebrating together that this material could not possibly have been shot in the middle of a battle. Instead of omitting the footage, Kuehl turned this to his advantage to make a point about the imagery. The commentary relates that the joining up of the two Russian armies to encircle the Germans happened so quickly that there was no time to film it, 'So it was re-enacted for the cameras.' The film we are watching is not a record of what happened, it is a propaganda celebration of what the Soviets wanted to show happening. This is *The World at War* at its archival finest, featuring film material but revealing its origins. The episode continues by explaining that as the noose tightens around the German pocket of nearly 250,000 men, Hitler insists that von Paulus cannot surrender but that a force will be sent to rescue them. No force came. And the Luftwaffe was unable to supply an army of this size from the air. A battle raged inside Stalingrad and slowly, street by street the Soviets press forward. In unimaginably dreadful conditions the German VIth Army, which had spearheaded victory in the West in the summer of 1940, is forced to surrender. The footage shows von Paulus himself surrendering and handing over his identity card – as the commentary explains, because the Soviets could not believe they had captured such a

116

Red Army soldiers hug as they surround the German army in Stalingrad –
but not for real, only for propaganda

senior German general and they needed proof of who he was. Tens of
thousands of German prisoners of war are shown shuffling off into a
miserable captivity from which barely one in twenty will survive. The
programme ends by quoting Hitler 'What is life? Life is the nation. The
individual must die.' Olivier's clipped delivery is ideal for a line like this.
The end of the film is both tragic and momentous. Kuehl today thinks
that he could have gone further with the archive film and that most of
the scenes shot by the Soviets of street fighting within Stalingrad were
probably staged, like the encirclement footage. The German material is,
he believes, authentic as the Germans thought they would win the battle
and wanted to record their victory. But the Soviets who thought they
would probably lose the city did not film until the battle was over
and then restaged parts of it.[142] But despite his later concerns, the
'Stalingrad' episode clearly displays an intelligent use of film as evidence
in the series and helps to makes its claim for archival authenticity.

Martin Smith joined *The World at War* as a film editor on 'Occupation' and then went on to direct two episodes, 'Red Star' and 'Nemesis'. Episode 11, 'Red Star' is one of the stand-out episodes. Isaacs had inserted the programme into the series after a prompt from Noble Frankland in their early discussions that the Nazi fighting machine was defeated not in the deserts of North Africa, nor in Normandy and Northern Europe, but on the Eastern Front. Smith worked with writer Neal Ascherson and editor Beryl Wilkins on this episode. Smith received a short written brief from Isaacs and an instruction to tell the story of the Russian civilian experience in the war. Isaacs then told Smith to come back to him when he had a rough cut.[143]

Smith read as much as he could on the war on the Eastern Front, concentrating on the siege of Leningrad and the Battle of Kursk, both of which would be at the heart of the episode. With the Soviet Union closed to the production, Smith would be reliant for archive film on a set of Soviet newsreels held at the Imperial War Museum and on film held by Stanley Foreman in his company ETV. And, like 'Stalingrad', it looked as though there would be no access to Russian interviewees. Smith rejected the idea of interviewing Russian émigrés as he thought they would bring an anti-Soviet agenda to an interview. He sent off regular requests every month or so through the Soviet Embassy in London and through the Russian news agency, Novosti, but held out little hope of breaking through the diplomatic freeze between Britain and the Soviet Union. And, in any case, if the Soviets could be persuaded to grant access, what level of editorial control would they demand over the making of the film? It would be impossible to grant much leverage here.

Smith viewed everything he could. He began to assemble his footage with Wilkins and came up with a structure for the film. Wanting to convey the humanity of the remarkable experiences of the Soviet people in the film but without talking heads, his researcher, Masha Enzensberger, a Russian living in London, suggested he look at some wartime Russian poetry that had recently been published. Smith was not a great reader of poetry, but felt that some of the poems did convey the

Soviet women mourn their dead: 'No country, no people, suffered so terribly in the Second World War as the Soviet Union'

immensity and emotion that would be difficult to evoke in narrative commentary. Isaacs was initially opposed to the inclusion of poems in the film as he thought it was too 'artsy' for a documentary of this sort. When he saw the poems in a cut, however, he immediately withdrew his objection.

The Tease of the programme begins with the lines 'No country, no people, suffered so terribly in the Second World War as the Soviet Union.' The film goes on to show the scale of the German advance and the racial war they unleashed. The Russian people were to become 'servants, natives, peasants and labourers' for the master race who needed extra living space in the East. As the Russians withdrew they destroyed everything they could that would aid the advancing German forces. In the first winter of the siege of Leningrad the suffering of the people of the city was immense. Some 4,000 civilians died each day. The film is full of statistics that are barely comprehensible. For instance, out

of 5 million prisoners captured by the Germans we are told that fewer than 2 million survived. When spring 1942 finally came, the lot of the Leningraders improved and morale went up. At the Battle of Kharkov, Stalin is defeated again and calls on the West to open a Second Front. But all the Allies can do is send supplies, many of which end up at the bottom of the sea after the high losses of the Arctic convoys. Following Stalingrad, the tide slowly turns but, as the Red Army advances, it comes across mass graves of those killed by the Nazis. Ascherson's commentary sums this up with fine precision: 'The Germans murdered Jews and communists. They murdered those suspected of supporting the partisans. They murdered hostages. After battle, in retreat, they just murdered.'

Smith wanted to use as much authentic Russian music as possible in this episode and all the vocal music is Russian. Carl Davis gave his music a Russian feel and some of his *World at War* themes were played on a balalaika. It is extremely effective. Film serves as evidence, not just illustration and a clip of a Soviet propaganda film evokes all the Russian heroes from a long history called upon to inspire the people to greater effort and endurance. With masses of aircraft, weapons and, most especially, tanks rolling off the production lines, the Red Army can at last confront the Germans. After the German offensive fails at Kursk in July 1943, 'the biggest tank battle in history', the Russian steamroller begins its march westwards. The commentary records 'In military terms it was Kursk that decided how the European war would end.' Frankland's point could not have been made more succinctly. As the Red Army advances the Germans lay waste to everything. The Soviets liberate the first of the big cities and find more graves. Heartrending film of distraught civilians is combined with a long Soviet poem to the dead. The episode concludes with Soviet propaganda footage of heroic and proud Red Army liberators being welcomed by cheering crowds. A Soviet marching song plays out on the audio track and the commentary sums it up with these words written by Ascherson, 'Russia was saved by its soldiers and by its people. But in the earth, never to welcome the coming of peace, lay 20 million dead.' Although 20 million was the figure universally agreed on

at the time, since the end of the Soviet Union, Russian historians have revised the total losses of the war upwards to 27 million.

The editing was completed and the fine cut was viewed by Frankland. He was pleased but he thought he had identified some staged scenes in the Russian footage. The shots were removed. Smith started to prepare his second film, 'Nemesis'. Then, to everyone's amazement, the Novosti agent in London, Felix Alexsayov, announced that he thought it would be possible for Smith to travel to Moscow to carry out some filming as long as he agreed to work with a Soviet film crew, and as long as Alexsayov could himself view the film before transmission. At last, more than a year after the expulsions of the diplomats, the Soviet authorities had relented. Isaacs agreed that the Novosti man could view the film only in order to correct any factual inaccuracies. And off went Smith to Moscow. He was given no choice of interviewees. They were

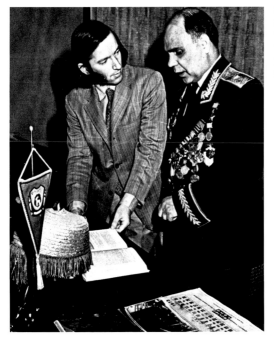

Martin Smith, the director of 'Red Star' and 'Nemesis', with Major General Antonov in Moscow

121

selected for him. He decided he would go ahead and film them and
see what they had to say, hoping they would not just spout Soviet
propaganda. Several senior veteran Red Army officers were offered to
him. They turned up in full dress uniform with rows of medals across
their chests. Then he went to Leningrad and filmed a couple more
soldiers and an English-speaking housewife. Smith returned to London
carrying the film cans himself. The episode was re-edited. Archive
sequences were removed, the new interviewees were added and
commentary was rewritten. None of the interviews sets the film alight. But
they are there and they provide a vital human link. Smith remembers that
he was 'overjoyed at having genuine Russian faces in the film and that
their use was effectively unrestricted'.[144] The new version was completed
almost a year after it had started production. Noble Frankland, Jeremy
Isaacs, Martin Smith and Neal Ascherson were all in total agreement that
viewers needed to be made aware of the suffering and the endurance of
the Soviet people and the role the Red Army played in destroying the
German armies in the field. Smith had delivered a supremely powerful
film in his directing debut. 'Red Star' is a film made from the heart.

 Other films could not be made this way. Certain episodes had
to be made much more from the head, to balance different arguments,
political directives and military strategies. Episode 24, 'The Bomb',
written and directed by David Elstein, was one of these. It deals with the
decision to drop the atomic bomb on Japan in 1945. Elstein had wanted
to make this particular programme ever since he first heard that Isaacs
was planning a World War II series. But to begin with he was asked to
make two of the early episodes 'Distant War' and 'Alone'. He enjoyed
producing these programmes very much and realised that to make
episodes work a director needed a clear sense of the history he wanted to
tell. Then he began to prepare for the film he was keenest to make.
Elstein had been very impressed with a book by the radical American
historian and political economist Gar Alperovitz, *Atomic Diplomacy:
Hiroshima and Potsdam* (1965). In this book, Alperovitz argued that
the dropping of the atom bombs was as much a political statement
towards Moscow as it was a means to end the war with Japan, that the

David Elstein, the youngest director on *The World at War*, who made three episodes

123

political agenda behind the decision in the transition from World War to Cold War was just as significant as the military motive. In the early 70s this was a controversial interpretation. In his programme, Elstein did not want to dwell on the making of the bomb during the Manhattan Project, or on the final Pacific campaigns on Iwo Jima, Okinawa and in Asia. He sought first and foremost to capture the argument about the decision to drop the atom bomb. Elstein wrote a Treatment along these lines and thinks today that it was brave of Jeremy Isaacs to accept this approach in the flow of a narrative-based history. In his programme the script and the intellectual framework of the debate about the bomb would come first, and this would determine what pictures were needed. The archive film would play a secondary role.[145]

Elstein went to America to film most of his interviews. Then he went on to Japan to interview some of the surviving members of the Japanese War Cabinet and film at Hiroshima. He returned and locked himself away in his flat, 'like a monk', for about a month to mark up the transcripts of his interviews to produce a paper edit, that is a script with all the selected interview extracts in sequence for the editor to assemble, linked by a guide commentary. The programme starts with the Yalta Conference and the beginnings of divisions between Roosevelt, Churchill and Stalin. After Roosevelt's death, Truman takes over as President and adopts a more bullish line towards the Soviet Union. As Henry Stimson, Truman's influential Secretary of War, was long dead, Elstein interviewed McGeorge Bundy who had been a minor official during the war but had co-authored Stimson's memoirs, as a way of describing what the Secretary of War had been thinking. In order to prevent Bundy from sounding like a historian in a series that was committed to testimony from eye-witnesses and participants, Bundy reads from the diaries, letters and telegrams sent by Stimson. It's a rather strange device to get into the mind of someone who is no longer there to speak for himself. A parallel figure in the series, John Colville, who had been Churchill's Private Secretary through the war, was allowed to describe his chief in his own way and in his own words. In 'The Bomb', Bundy is cast as a substitute for Stimson and it comes across as rather strange.

The episode proceeds through long interview extracts to outline the argument within Washington as to how the bomb should be deployed. Should the Japanese be warned of its existence in advance? Could they keep the Emperor as some sort of constitutional monarch if they surrendered? If so, should they be told this, as James McLoy proposed, as an inducement to surrender? Or should they only be told once peace negotiations had begun, as Stimson believed? Curtis Le May, one of the most gung-ho American commanders during the Cold War, who had taken a very aggressive stance during the Cuban Missile Crisis, gives an interview, explaining that US bombers had the ability to fly over Japan and hit any target at will. By the beginning of September,

124

he recalls, they would have destroyed every target on their list and he believed at the time that the war would soon be over. As Truman sails to Europe to attend the Potsdam Conference, the film outlines the options confronting him, rather like a historical paper might do. Parallel to these debates, the film follows the discussion within the Japanese War Cabinet about whether to surrender and if so, how to do this and win the best terms for the nation. There was a division in Tokyo between militant supporters of the war who wanted to fight on until every Japanese person was dead, and a peace party that wanted to open negotiations with Washington. Peace feelers were sent out through the Soviets. The Americans had broken the Japanese codes and read their communications so knew they wanted peace, but only at the right price. At Potsdam, when Truman tells Stalin that the US has the bomb, the Americans are disappointed when the Soviet leader fails to react. Truman leaves Potsdam and orders the dropping of the bomb.

The film then changes gear from the political debate to become a far more personalised account. Paul Tibbets, the pilot of the Enola Gay, the B-29 bomber that dropped the bomb, describes the flight to Hiroshima in detail. It was a bright, sunny morning. He describes how it took fifty-three seconds for the bomb to land and that when it exploded the blast was as though someone had got hold of his aircraft and given it a shaking. There are interviews with several Japanese survivors of the bomb along with terrifying evidence of what it was like to be atom-bombed. But it takes some days for the Japanese Cabinet to realise the scale of the bombing. The Americans then drop another bomb of a different type, a plutonium bomb, on Nagasaki. Now we hear from the youngest member of the War Cabinet, Toshikazu Kase, that the Emperor himself intervened between the divided factions and insisted on surrender. The film shows the Japanese people, heads bowed, listening to the Emperor's radio broadcast saying 'We must endure the unendurable.' There is then colour footage taken by US medical cameramen after the war of Japanese civilians suffering from severe burns and from radiation sickness, a by-product of atomic warfare that, we are told, 'the Americans had not foreseen'. Finally, at the surrender

125

ceremony on board the USS Missouri in Tokyo Bay, General MacArthur pronounces 'These proceedings are over.'

This episode is very different to most others in *The World at War* in that it concentrates on the political discussions within the American leadership about what strategy to adopt with regard to the bomb. And it explores the political discussions in Tokyo between the different factions about whether or not to surrender. This means there is a great deal of interview material in the programme. If the normal balance in the series was about 70–30 archive-to-talking head, the balance in this episode is more like 20–80. But it is a sign of the confidence of the series makers that a crucial historical decision like this is afforded such detailed analysis, describing the politics of the beginning of the nuclear era – an era that would dominate the second half of the twentieth century. The programme is low on narrative entertainment. It is high on political analysis. It is an essay film. But it is strong for being that. And like the rest of the series, it benefits from being made by a committed film-maker at a time when so many witnesses to crucial events were available to recount to powerful effect what they had seen and heard.

12 The Holocaust

Jeremy Isaacs had included a programme on the killing of the Jews, named 'Death Camps', in his very first outline of the series in April 1971. In this draft Treatment he had said that the episode would 'recount how the Germans did it'.[146] Isaacs had intended to make this programme himself but after a year of production he decided that, with family connections to some of those who had died in the camps, he was too emotionally involved with the subject and resolved to ask another director to make this episode.

Michael Darlow was at heart an independent film-maker. He wanted to do things his way and through his award-winning series *Cities at War* he had evolved his own view on how to approach historical subjects on television. Isaacs asked Darlow to join *The World at War* to direct the episode about life in occupied Europe. Darlow's wife, Sophie, had grown up in Yugoslavia and had been sent to Germany in the war, so the subject of how the conquered people of Europe faced life under the Nazis fascinated him. Isaacs and Darlow agreed that they didn't want to take an overview approach that looked superficially across the whole of Europe, but rather intended to drill down and tell in detail the story of one country. France was the obvious country to focus on, but Marcel Ophuls had only recently released the four-hour film *The Sorrow and the Pity* (*Le Chagrin et la pitié*, 1969) and both men felt that an episode on the French occupation would be repeating a story that had already been powerfully told. Darlow was drawn through his wife's experiences to the subject of Yugoslavia, where there had been

determined resistance to the Nazis. But Isaacs felt that viewers would
find it hard to sympathise with this story. They looked at Denmark but
decided it was too atypical. So they settled on Holland. Professor Louis
de Jong, a leading Dutch historian on the occupation, was taken on to
provide specific historical advice on the subject, about which little was
known outside the Netherlands.

The story of the Dutch people during the war that became
episode 18 'Occupation', was not one of great heroics or mass suffering
like in Eastern Europe. But the film carefully and evocatively shows
how a humane, democratic nation faced up to occupation by a racist,
authoritarian regime. Although the German occupation at first seemed
benign, the film explores how, as the Nazis tightened their grip, Dutchmen
and women had to make choices between cooperation, collaboration or
outright resistance. Darlow wrote a fifteen-page Treatment in August
1971. It was assumed from the beginning that not much archive film
would exist to illustrate this story. John Rowe, his film researcher, initially
thought he would be able to find only a few minutes of footage to cover
the entire programme. But at the Netherlands Film Museum he began to
discover much more material than anyone had expected, including
dramatic home-movie footage of protestors surreptitiously painting the
signs of the Orange family, symbols of freedom, on walls.

Darlow was convinced that the episode should foreground
the interview testimony from Dutchmen and women as they told their
stories of the options they faced. Some joined the Dutch Nazi Party, the
NSD, and willingly supported the occupying regime. Many civil servants
carried on working for a regime of increasing harshness and brutality.
Others listened in secret to illegal broadcasts from London, but felt
powerless to resist. At the heart of the issue was the Nazi treatment
of the Dutch Jews, of whom more than 100,000 out of a prewar
community of 140,000 perished during the war. Dutch Jews describe
how members of their family were rounded up and shipped out. In the
programme, footage of people being sent off 'to the East' by train is run
in silence. Some shopkeepers and transport workers went on strike to
protest but this did little to stop the process of forced evacuation. The

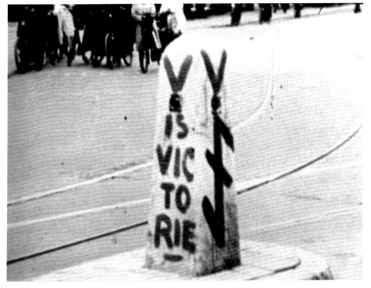

The Victory sign daubed on a bollard in Holland as a gesture of defiance, recorded on a home movie

commentary records that 'The trains ran on time despite the call for strikes.' One Dutchman, R. M. Van der Deen, says in the film 'We failed as a nation. We let down the Jews.'

'Occupation' is an unusual film in *The World at War*. There is little combat action. It tells with subtlety and power the story of the moral choices facing the Dutch population. It was the second episode that went into production alongside Peter Batty's 'France Falls'. This programme told of military victories and defeat in a very different way. But 'Occupation' introduced Darlow to the moral issues around collaboration and the evacuation of the Jews. When he had finished it, Isaacs asked him to take on the episode on the Holocaust that he had decided not to make himself. In the summer of 1972, Darlow immersed himself in reading as much about the Holocaust as possible. In August he wrote a 25,000-word document, not a Treatment but what he called an 'Argument for a film about Nazi concentration camps'. In this

document, and partly out of his experience of making 'Occupation', he
made it quite clear that

> this is not primarily a film about the suffering of the people in the
> concentration camps. It is an attempt to set down what happened and
> above all, why. So it is above all a film about the organisation, and [the]
> people behind the organisation of a calculated act of genocide.[147]

Darlow did not want the film to dwell on the question that had
dominated the post-war debate about the extermination camps: 'What
kind of inhuman monsters could do this'? His film was to be more
uncomfortable than one simply about 'victims'. He intended to examine
the thinking of the perpetrators of the crimes. And he also wanted to
know why the Allies, when they knew the killing was going on, had
done nothing to try to stop it. He later summed this up

> I wanted to demythologise events which because of their unique horror had
> taken on the aura of the inexplicable. I believed that upon examination
> even the Holocaust, supremely evil and terrible though it was, must have
> been just as much the product of mundane, confused, but in themselves
> recognisable, human actions as other atrocities in history. This meant that I
> would need to include not only the stories and experiences of the people
> who had suffered, the victims – vitally important though they were – but
> also, perhaps more importantly, the stories and explanations of the
> perpetrators.[148]

Darlow ended his 1972 'Argument for a film' by writing that the
Holocaust 'happened on our continent, in our generation, for perfectly
ordinary and explicable reasons. It will probably happen again – and we
shall be even more guilty than the last time.'[149] Darlow's film was going
to have a strong sense of morality to it.

 At the time there had never been a detailed, analytical, no-
holds-barred programme on British television about how and why
the Holocaust had taken place. Darlow recognises today that most

informed people in the early 1970s would have known that 6 million Jews were exterminated during the war and would have known of the terrible images of the liberation of Belsen that were recorded there. But Darlow wanted to portray the event as even colder and more disturbing.[150] And in the early 70s, the Holocaust had not become one of the central aspects of World War II as it would in most serious studies of the subject in the latter part of the twentieth century.

Darlow's journey into historical film-making that had begun with *Cities at War* and had progressed through 'Occupation' came to its conclusion with 'Genocide'. 'Obviously we shall use library film and stills – but not too much', he wrote in his Argument.

> The endless repetition of horrors simply becomes unbearable … . But ultimately the film will depend on interviews, not too many people ideally but rather the progress of a small number of individuals who can typify the experience on both sides.[151]

This was the core of what Television History was about for Darlow – presenting the experience, thoughts and rationalisations of individuals. Archival material played a secondary, supporting role. He didn't want to feature the simple-minded or sadistic thugs who are easily led into acts of violence and turn up in every age to perform beatings-up or killings or atrocities. He wanted to hear from ordinary people who carried out their work of killing for ordinary reasons. Their memories were what Darlow was interested in. He freely admits today that he was making this programme at the perfect time. Although the senior people were all dead, those on the next rung of the ladder were now of an age to wish to talk, to explain and justify what they had thought and why. And he realised he was working for a commercial television company that would give him the time to try to find such people.[152]

Isaacs let Darlow have the time he needed to pursue his quest. This immediately put immense pressure on the researchers working on the production. Knowing that the hunt for the perpetrators of the Nazi genocide would take many months, Darlow himself went off and

pursued other television projects, first a drama documentary about Turner with Leo McKern, also for Isaacs at Thames, and then a BBC *Omnibus* about François Truffaut shot over a long period during the production of *La Nuit américaine* (English title: *Day for Night*, 1973). Meanwhile his researchers tried to track down the most extraordinary victims and the most ordinary perpetrators of the Holocaust. Drora Kass was taken on as a freelance researcher in Israel to find those who had suffered and survived the camps. Sue McConachy, the German-speaking researcher who had found the men and women closest to Hitler in the bunker, had the task of tracking down the Nazis who had been part of the killing. This meant pursuing ex-members of the SS.

At the end of the war, the SS had been declared a criminal organisation and many of its officers had been hunted down and prosecuted. The War Crimes Prosecutors Office in Frankfurt and the Simon Wiesenthal Centre in Vienna put McConachy on to several ex-SS men who had been found guilty in the post-war tribunals and served their time. Many others had escaped prosecution and were living as regular citizens in the 'new' Germany. Through various networks, McConachy and Charles Bloomberg, the writer of 'Occupation' and 'Genocide', opened up channels to ex-SS officers who had evaded capture at the end of the war. McConachy later wrote that if she just turned up to visit them, few people turned her away, 'Basically they didn't really want to talk to me but if a girl turns up on the doorstep and looks kind of harmless, they'll let you in.'[153] But gaining access opened up further moral dilemmas. One SS officer agreed to meet McConachy but refused to appear on camera because of the risk that this would invite the authorities to prosecute him. After their meeting, the local Nazi hunters asked McConachy for his address. The researcher refused to pass this on as she felt it would be a betrayal of the trust that had been established between them. She further reasoned that, if she had been able to contact him, others would easily be able to as well. However, her decision meant that, the team had helped a potential war criminal remain free.

McConachy faced a different dilemma with Karl Wolff, who had been adjutant to the head of the SS, Heinrich Himmler, and one of those very close to the ideology of the SS. Sent on several wild goose chases, she spent months pursuing him without luck. Then he walked into the Berlin hotel she and Darlow were staying in and introduced himself with the words 'I hear you are looking for me?' Imagining from his wartime reputation that he would be a real monster, McConachy was astonished that he turned out to be quite charming. Wolff had helped the Allies at the end of the war and so had evaded prosecution at the time. But he had been arrested in the 1960s and had spent some time in a German prison. He had a strong desire to explain and justify the ideology of Aryan superiority that lay behind the SS. McConachy met Wolff on several occasions over many months and felt she had to win his confidence. She described him as a lonely old man who rather liked the idea of confiding in a young female who appeared so interested in what he had to say. At one point he told her that being young and blonde she was of good Aryan breeding stock.[154] She grew to detest him as an individual. However, she felt she had to play along and not to argue with what he said in order to make him feel he could trust her when it came to giving an interview. She found this a profoundly unpleasant experience, but justified it to herself in that she was only acting in a professional manner in order to secure the interview.

Darlow and McConachy particularly wanted to get Wolff to relate on camera an incident when he and Himmler had been present at a mass killing of Russian prisoners-of-war near the city of Minsk. A group of POWs had been lined up in front of a large pit and shot, falling into the pit. Then another group of prisoners had been lined up and shot. Himmler had apparently been fascinated by the execution and had stood on the edge of the pit watching the bodies fall into their own grave. Wolff said that, unlike his boss, he was horrified by what he witnessed. At one point, Himmler was so close that the blood and brains of one of the murdered victims splattered over his coat and he turned away, revolted. Wolff had told McConachy this story one evening when she had been visiting him. At the time she had been standing in his

133

Karl Wolff, Himmler's adjutant, the most senior SS officer in *The World at War* – he took some persuading to appear

kitchen, making him some scrambled eggs. Telling this to a young Englishwoman in the intimacy of his kitchen was one thing. Telling the story on camera was quite another.

Darlow decided to allocate a whole day to filming the interview with Wolff as he knew it would be difficult. During the morning, Wolff was allowed to explain the ideology of the SS. After lunch, he seemed more relaxed and a little way into the afternoon's interview, conducted by McConachy in German, Darlow told the cameraman to put on a new roll of film and prompted his researcher 'Now pitch it to him.' So she asked him to describe the shooting at Minsk at which Himmler was present. Wolff did a double-take and appeared astonished, clearly having forgotten that he had ever told her this. He said he had no idea what she was talking about and was still stumbling when the film in the camera jammed. It took a few minutes for the assistant cameraman to sort this out and, maddened, Darlow and

McConachy were convinced that he would resist recounting the experience now he had had a moment to reflect. But to their surprise, when the film was reloaded, he said 'I am a man of honour and if I have told you this story, I shall tell it again' and he duly did so on film.[155] It appears at length in 'Genocide'. McConachy was pleased, on reflection, that she had had time to make his own decision to go ahead and tell the story and had not been bounced into it. But overall McConachy remained unhappy about working with Wolff and the other SS veterans because she had had to be dishonest about her own feelings, playing along with them in order to win their confidence. 'In almost every other programme I've been involved in, one could be pretty honest about what we were aiming at', she later said in an interview.

> But in that situation it was difficult. I hope I didn't appear to totally agree with what they were saying, but I never actually openly disagreed with them. I knew if I did then this very, very tentative agreement that one got from them to appear and be part of the programme would be shattered.[156]

135

Despite her qualms, the interview with Wolff, which used twenty ten-minute magazines of film, is an important record for the series and for posterity, detailing how a senior SS official felt about the events of which he had been a part.

Darlow has a different take on the morality of dealing with the interviewees in 'Genocide'. He certainly built up some sympathy for the old men he was meeting, even if they had been party to 'unspeakable acts of evil'. He believes that to carry out a good interview one has to have a degree of empathy for the interviewee. A part of the brain can, of course, retain a rational detachment and take a more distanced view on the guilt they bear. He likens this to the task of an actor who has to have empathy for the part he is playing, even if the part is that of an evil villain. Despite the ambiguity involved in interviewing war criminals, Darlow felt his first moral responsibility was to the truth of the story and only then to the individuals they were interviewing. Darlow hated Wolff for his racism and his sense of superiority but believed that it was

his job to put Wolff's views on the record. He wanted to get at the harsh reality of the mass murders not portray a sentimental version of the Holocaust. He was also aware that some people were starting to deny that the Holocaust had ever taken place so that it was even more vital to get the perpetrators to confess what they had seen and done. It could always be claimed that the victims had made it all up. But this could not be said of those who had carried out the crimes. The other two SS men interviewed were Dr Wilhelm Höttl who had come to the team through the Frankfurt Prosecutors office. He was a bureaucrat who had helped to make the whole system of expelling Jews and transporting them to the death camps operate more efficiently. And there was Lance Corporal Richard Böch, who describes in detail watching how the gas chambers at Auschwitz operated. He protested when his friend sprinkled the Zyklon B cyanide capsules through the roof of the gas chamber and a caption at the end of the film reveals that he had been 'exonerated by investigators of Nazi crimes' and 'commended for steadfastly refusing to take part in the killings'. Darlow called him 'the good Nazi'.

136

The five principal Jewish interviewees in the programme each describes a different aspect of the extermination process. Avraham Kochavi is a Polish Jew who recounts how the Jews were separated from the rest of the community following the German invasion of September 1939 and the rule of terror that was then imposed. He describes in graphic detail the horror of the train journey to Auschwitz during which his focus on protecting his father made him immune to the sufferings of others around him. Rivka Yosilevska was another Polish Jew who tells the remarkable story of how she miraculously survived a mass shooting by the Einzatgruppen while her baby and whole family were murdered around her. For Yosilevska, who had been left for dead lying among a pile of corpses, telling her story naturally proved to be an immense strain. She had first related her experience in public at the Eichmann Trial in Jerusalem some ten years before, after which she had suffered a heart attack. But she insisted on telling the story on camera for a second time as she felt it 'her duty' to bear witness to what had happened to her

Dov Paisikowic, a member of the Jewish Sonderkommando in Auschwitz

137

and millions of others. Darlow knew that if he finished the interview at the end of the mass shooting (the only section he wanted to use in the programme), he would leave her in great emotional distress. So he carried on filming until she had described her recovery, the start of a new life and a new marriage in Israel. He felt that his responsibility towards Yosilevska was such that, if she agreed to bear the pain of reliving this remarkably traumatic event, then he had to help her get through the darkness and out onto the other side. As a consequence, her full story is recorded on film for posterity.

Two other Jewish interviewees contributed their extraordinary stories. Thomas Vrba, a Czech Jew, imprisoned in Auschwitz as a teenager, had developed a brash exterior to somehow survive the horrors that he had witnessed. And Dov Paisikowic, a Hungarian Jew, tells of serving in the Sonderkommando, the squads of Jews who were forced to assist in clearing out the gas chambers and carried thousands of bodies to the ovens for burning. Both men talk in

a relatively matter-of-fact way about what they had witnessed. Darlow realised that for many Jews it would be difficult or shameful to see that other Jews had assisted in the work of the extermination camps. But he did not want the film to avoid complex issues. So their stories are in many ways at the heart of the episode. Darlow also interviewed Primo Levi, who makes a brief appearance in the programme. But, to Paisikowic, who was transferred from Auschwitz and eventually liberated by American soldiers in a camp in the West, Darlow gives the last the words of the film: 'I bless every day that I live as every day is pure profit. I could say I'm 27 years old today because life before the camps doesn't count. I was reborn after the liberation.'

Apart from the power of the testimony recorded by Darlow and his team, the strength of the 'Genocide' episode comes from its simple structure. It begins with the development of the SS in the 1920s as an elite within the Nazi party with a philosophy of racial purity and Aryan supremacy. Wolff carries much of this part of the film but says 'never did it occur to us that it would come to exterminating anyone'. But through the Nuremberg Laws and Kristallnacht, the film tells how the Nazis in power turn up the pressure on the Jews in Germany. When the war starts in Poland, the Nazis then find they have millions more Jews under their rule and ghettos are built to segregate them from the rest of the population. Starvation and disease soon initiate the killing process. When Hitler invades the Soviet Union 'another racial war' generates 'more resettlement and mass deportations'. Wolff comments 'We found 3 million Jews in Poland and 5 million in Russia. How could we deport so many?' This is where the mass shootings begin and Rivka Yosilevska describes her appalling experience. And Wolff tells the story of Himmler's visit to one of these shootings at Minsk. The archive footage, in reality that of other shootings at other places, is run in silence with only the sound of gunshots. But shooting so many Jews was too slow and stressful for the Nazis so at the Wannsee Conference it is agreed that the 'final solution' will be to round up and deport millions of Jews, gypsies and others to specially built extermination camps in the East. Auschwitz is one of six of these

death camps built to kill on an industrial scale. Photographs show the
building and design of these camps. Kochavi describes the horrendous
journey to Auschwitz. The detailed process of extermination is
recounted by the 'good Nazi' Richard Böch, Thomas Vrba and
Sonderkommando Dov Paisikowic.

Darlow today remembers that one of the most difficult aspects
of making this film was finding anyone on the Allied side who could
explain why nothing was done to prevent this wholesale slaughter. Lord
Avon, who as Sir Anthony Eden was British Foreign Secretary during the
war, relates in evident discomfort how they found it difficult to believe
the stories that were coming out of Europe. Eventually, when the
evidence became overwhelming, he and his counterparts decided to issue
a statement making it clear that everyone responsible for these killings
would be prosecuted after the war was over. When he read this out in
the House of Commons he describes how surprised he was at the effect
it had, with the House standing in tribute. With the half hint of a smile
he concludes 'Well that was something we could do.' It was a moment of
irony but seems tame in the context of such a powerful documentary.
However, a single film offered little further opportunity to debate the
questions that have been at the heart of much scholarly debate about the
Holocaust in the 1990s and 2000s – what *could* the Allies have done to
stop the killing?

'Genocide' ends with Paisikowic describing the chilling details
of the gas chambers and ovens. But as the Allies close in from East and
West, the Nazis try to destroy the evidence of extermination. Auschwitz
is abandoned and the survivors are liberated by the Red Army. In the
West, in April 1945, Belsen is liberated by British troops and the full
scenes of horror are shown in the programme, with piles of corpses
being bulldozed into mass graves. With Paisikowic's words about his
new life after surviving the camps, the film comes to an end. 'Genocide'
is certainly uncomfortable, full of moral ambiguities and dramatic
testimony, and some of the harrowing archive material is difficult to
watch. It is not a complex film but it is certainly unflinching. It is a
tough subject and Darlow, who was supported by Jeremy Isaacs at

139

Filming at Belsen concentration camp: these images from 'Genocide' shocked many when shown at 9.00pm

every stage throughout its making, was uncompromising in his approach. Forty years later it is still recommended as one of the best single films for teachers to show about the Holocaust.[157] Darlow, however, never made another archive-and-testimony-based history documentary.

'Genocide' was first shown on Wednesday 27 March 1974 on the ITV network at 9.00pm. The programme went out without any commercial break, preceded by a warning requested by the IBA to alert viewers to the disturbing scenes to follow – one of the first times such a warning was transmitted. The response was varied. Nancy Banks-Smith in the *Guardian* wrote that the programme was 'on the borderline of the unbearable … I found it, in no narrow sense, wholly obscene and hardly fit to be seen'. Mary Malone in the *Daily Mirror* went even further, writing that it was 'Helpless, hopeless, heartrending, horrific. Please, now that Episode 20 is over, can we shudder our way back to fiction –

and forget?' Other critics took a different view. Peter Lennon of the *Sunday Times* wrote:

> The justification for showing 'Genocide', which contained the most sickening and harrowing footage I have seen on television, must surely be that it is necessary for us to be reminded, before the events take that neutralising step into the safety of distant history, what a generation still living was capable of.

Sean Day-Lewis in the *Daily Telegraph* wrote:

> The compilation was nevertheless abundantly justified. First as showing exactly why the war against Hitler's Germany was necessary and, more importantly, as a warning which needs to be repeated for the benefit of every new generation approaching adulthood.[158]

Some viewers also wrote in to complain. One of them wrote that 'after half an hour my breaking heart, and my blinding choking tears, made me turn off'.[159] It was clear that many viewers did not want to see such a harrowing programme on a means of communication primarily used for entertainment. Others praised the bravery of the team, of Thames and ITV for screening such a powerful film at primetime. Mary Whitehouse, who at the time was beginning to turn the National Viewers' and Listeners' Association into a powerful lobby, also wrote to object. She quoted a letter from one of her members who had never seen 'such a revolting, horrifying and disturbing programme before. I felt positively nauseated and shocked and slept only fretfully during the night.' The viewer went on, 'The fact that this was a programme of important historical interest I do not think is relevant, since we are concerned surely with the peace of mind of the majority of viewers.' Whitehouse concluded: 'I trust you will find this of value in assessing the level of violence people find acceptable.'[160]

The debate about whether images of the Holocaust should be broadcast at primetime when any viewer can stumble across them at

home in their own living room has continued ever since. Jeremy Isaacs and his team felt they could not make a series on the war without showing the horror of these scenes, that it would have been an abnegation of their duty *not* to show them. 'Genocide' was one of the first programmes to use such sickening images in Britain and in many, though not all, of the countries to which it was sold. It is a great tribute that it is still one of the best introductions to the subject forty years later.

13 Conclusions

At the end of episode 24, 'The Bomb', the military 'proceedings' of World War II come to an end. But from the very beginning, Jeremy Isaacs had planned two concluding episodes to look back and ask questions about who had really won the war and what the experience of war meant to those who had survived it and for the families of those who had not. Jerry Kuehl made episode 25, 'Reckoning', and Isaacs himself made the last episode of the series, 'Remember'. The two episodes were made simultaneously, with Beryl Wilkins editing 'Reckoning' and Jeff Harvey editing 'Remember'. They were produced quickly after the series had already started its run on ITV and on US television. For these last two episodes film researcher Raye Farr was able to supply some extraordinary new film that she had discovered in the Bundesarchiv in Koblenz some eighteen months earlier. Having spent so long at the German film archive viewing almost everything that related to the war, the archivists then admitted that there was a collection of film cans that had been returned from the Library of Congress a few years before that even they had not had time to view. Together with the film archivists, Farr started to watch this material. It was not clear exactly what this footage was and how it happened to be in a single collection. It appeared to consist mostly of rushes that had not been edited or censored by the Propaganda Ministry and so was pretty much what the cameramen had filmed. Much of it had been shot on the Eastern Front, although there was also footage from North Africa, Yugoslavia and from the West. The material was on 16mm (most

German propaganda filming had been on 35mm) and it had been sent back from Washington to Koblenz as part of an initiative from the Kennedy years to return wartime material to Germany. Farr thought the footage was fascinating – because it had not been edited or formally processed through the official channels, it revealed far more than edited newsreel or propaganda film ever could. However, there was a problem. Because the 16mm prints were the only copies the Bundesarchiv had, it became their master material. Everything, therefore, had to be duplicated before Farr was given access to it for *The World at War*. Isaacs tried to speed the process up by offering to pay for copies to be made but the archivists at the Bundesarchiv insisted on copying everything at their own speed. This process took a year and a half, with the consequence that footage that could have featured in earlier programmes like 'Barbarossa', 'Red Star' or 'Desert' was simply not available when these programmes were made.[161] Although this was a loss, it meant that the two concluding programmes had access to powerful new material that was different to anything in the earlier episodes.

144

In 'Remember' some of this footage is used to tremendous effect. A sequence shows German soldiers entering a Russian village and blowing up some of the houses. Then the villagers are rounded up. The men are separated from the women and children. The two groups are marched off. Over tearful farewells, the viewer knows that these women will probably never see their men again. The cameraman keeps filming. It was a scene that must have played out in thousands of villages on innumerable occasions. Isaacs lets the film run and his narration simply comments 'Another road. Another village. Same orders.' In another sequence using Farr's Bundesarchiv discovery, German soldiers are throwing potatoes to Russian prisoners. They fight each other to grab the scraps of food. It is an extraordinary view of what humiliated, starving men will do to try to survive a little longer. But the commentary notes that, like millions of other Russian prisoners, most of these men will soon die of starvation.

For 'Reckoning', Kuehl asked Raye Farr to find images that revealed what defeat looked like in Germany. There is colour footage of

An army in defeat: German troops surrendering to the Americans 145

the ruins of Berlin. An aerial shot over destroyed houses goes on and on, and on and on. There is memorable film of a German convoy of troops surrendering to American soldiers. It is haphazard, chaotic, some men are at the end of their tether, others are still upright and proud. Parts of it look like scenes from a movie. But there is a realism in the chaos that gets close to what must have been the experience of defeat for millions. In the confusion two well-fed men pass the camera in the striped uniforms of concentration camp prisoners. The commentary suggests that they may be SS camp guards trying to disguise themselves to escape. The early summer of 1945 was very warm in continental Europe. There is footage of Berlin street cafes packed with smart Berliners in their colourful best, drinking coffees and beers. They are the survivors. Attractive, well-dressed women chatter enthusiastically with Allied soldiers. This is another view of defeat. The programme includes many top-level interviewees. Averell Harriman talks about Stalin at Potsdam.

Stephen Ambrose
HISTORIAN

146 Stephen Ambrose, the only historian used in the series in 'Reckoning'

Lord Mountbatten remembers being told that the Americans were going
to drop the bomb and that, as Supreme Commander, Southeast Asia, he
must prepare to re-establish civilisation and the rule of law and order
over a huge area of the globe and over hundreds of millions of diverse
peoples. Lord Shawcross talks about the Nuremberg Trials at which he
was a leading prosecutor. The trials offered retribution, Shawcross says,
but they also laid down the rules of international law for the future.

Most interestingly, this programme also features the only
historian speaking as a historian in the series, breaking the 'no pundits'
rule Isaacs had set at the beginning. When the programme was first cut it
was slightly under-length. Kuehl had read a book by Stephen Ambrose,
the American historian, *Rise to Globalism* (1973) which he felt
expressed some of the big-view, macro political points he wanted to
make. So he suggested to Isaacs that they should try to interview
Ambrose. Isaacs readily agreed, acknowledging that rules are there to be

broken. Ambrose was flown to London and, then in his mid-thirties with long hair and in a thick white pullover, was filmed by Kuehl.[162] His well-articulated pieces tie the slightly rambling programme together with a dramatic eloquence. Many of the ideas he expressed would have been entirely new and fresh to an audience in the early 70s.[163] Ambrose talks of the long European civil war from 1914 ending in 1945 with the Americans and Russians meeting on the Elbe river. He argues that no European nation won the civil war, but that it was the US and the Soviet Union that were effectively left in control of the continent of Europe. Ambrose speaks about the US wanting to rebuild the Japanese economy in 1945 as quickly as possible to ensure that it remained within the American orbit. He describes the Soviet Union emerging as a great power at the end of the war. He talks of an exhausted Britain getting very little out of the conflict, beyond the moral claim that for a year the nation had stood alone against Hitler when others were capitulating to the Nazis. He describes America as the real winner of the war. The commentary adds that the US economy had doubled in size during the war and that America had 'More food than it can eat. More clothes than it can wear. More steel than it can use.' And, of course, in 1945 America alone had the atom bomb and had used it. 'Reckoning' ends its historical overview of the winners and losers of World War II with moving pictures of men and women being reunited around the world. It is the sort of sequence that film editors love to edit, with an abundance of outstanding images cut to Carl Davis's music. To this Kuehl adds Ambrose saying, 'The most important single result of World War II is that the Nazis were crushed. The militarists in Japan were crushed. The fascists in Italy were crushed. Surely justice has never been better served.' With war in Vietnam still dragging on, the commentary concludes: 'For thirty years now there has been peace ... in Europe.'

'Remember' completes the series overview of the experience of war. Veterans look back and remember. One old soldier can still hear, see and smell the war. Another, a sailor, still wakes in the night with nightmares of the men lost at sea. A permanently disabled American veteran says sympathy is something you find in the dictionary 'between

shit and syphilis'. But the programme also evokes the comradeship of
war. Several veterans, including Noble Frankland, this time being
interviewed himself, talk of the bonds that are built up between men in
the face of intense danger, like those in the crew of the Lancaster bomber
in which he served. There is footage of German and British veterans at
an Afrika Korps reunion in the 1970s – 'Old comrades. Old enemies.
Plenty of beer.'

'Remember' suffers from trying to provide a round-up survey
of the statistics of wartime losses:

> Britain and the Commonwealth lost 480,000 dead of which 60,000 were
> civilians … Germany lost nearly 5 million dead. Two and a half million
> killed in action. One and a half million in Russian prison camps. A half
> million from Allied bombing. A half million at war's end … 15 million
> Chinese. One and a half million Yugoslavs. 5 million Jews.

And so on. The numbers are too overwhelming. They are difficult to
absorb. Against this, however, interwoven throughout the film is one
man's account of how his mother received the news that her husband
was missing in action. Later he is identified as dead. He reads the official
telegrams, then the letter from the King. Then he reads the last letter the
man had written to his wife. He was an airman just about to 'come off
ops'. It was his last combat mission. One death stands for millions. In
total we are told, 55 million people died in the war. This last episode
ends where the series began, with aerial footage of the French village
of Oradour-sur-Glane. To photos of the dead on the local memorial,
Olivier reads the final words of commentary: 'They killed 600 men,
women and children. The day the soldiers came.'

148

14 Aftermath

The World at War began transmitting in late September 1973 in the US and on 31 October on ITV. The series received extensive praise in Britain and around the world. Reviewers like Chris Dunkley in the *Financial Times* picked up on the moral equivalence demonstrated in the series, which suggested how similar it was to be bombed out in London, Berlin or Tokyo. 'There is in fact very little editorialising in the series, and this is where much of its power and its value lies', Dunkley wrote, also praising the use of archival film, concluding that the series 'would seem to be the definitive version [of World War II]'. After only two episodes, Clive James wrote in the *Observer* that *The World at War* 'has already established itself as a documentary series of central importance'. Many reviewers were still praising the series after its marathon twenty-six-week run. The *Daily Telegraph* wrote 'This magnificently well-made series has proved itself to the last, the most genuinely educative survey of the 1939–45 period yet produced on television.' The *Daily Express* added 'There is no superlative that adequately captures the mood of *The World at War* series.' In the United States the response was equally positive. The *Baltimore Sun* looked back on the series as 'the best war documentary ever shown on television'.[164]

The series did well when it came to awards. It won a Royal Television Society and a Broadcasting Press Guild Award for the Best Documentary Series. In the United States the series did especially well, winning an Emmy Award (the television equivalent of the Oscars) and a Peabody. Only at the SFTA did it not come up trumps. There was an

The Society of Film and Television Arts

Yet more recognition has come the way of *This Week's* programme *The Unknown Famine*. Viewers of the Society of Film and Television Arts award presentations on March 6 will have seen reporter Jonathan Dimbleby receive the Richard Dimbleby Award for the year's most important personal contribution on the screen in factual television.

The Unknown Famine team of Jonathan, 'Butch' Stuttard, Peter Bluff, Stan Clarke, Ray Sieman, Brian Mongini and John Edwards have already been honoured with the programme being named "The Great Documentary of the Year" by French Television, and Ray was voted TV News Film Cameraman of the Year by the Royal Television Society.

Alan Afriat receiving his award from Princess Anne

Elkan Allan, in The Sunday Times, gave the programme a special award 'for proving the significance of the medium' and on London Broadcasting said: "The Unknown Famine was the most impressive example of television having an effect in recent memory. Television appears to go in one ear and out the other endlessly. *The Unknown Famine* proved dramatically this is untrue. The £1 million (Continued on page 4)

There is a lot of interesting news about Thames people around this week. So, exceptionally, we have produced a double-sized *Newsletter*.

Thames award winners at the Society of Film and Television Arts awards ceremony at the Albert Hall. Left to right John Edwards, Mr. Brian Young (Director General of the IBA) Alan Afriat (winner of the Technical Craft award for his work on *The World at War*), Brian Tesler, Jonathan Dimbleby, winner of the Richard Dimbleby Award and Lord Aylestone, (Chairman of the IBA.)

Jonathan Dimbleby receiving his award from Princess Anne. Ian Martin is on the left, acting in his capacity of Vice Chairman of the SFTA.

Thames Newsletter reports the SFTA Award for Alan Afriat

issue with a series of this length as to in which year it should be entered. In 1974 it was nominated for the Best Factual Series Award but failed to win. The same happened the following year while the 'Genocide' episode was nominated for the Best Factual Programme Award but also failed to win. The only success was for Alan Afriat in the Technical Craft Awards where he won for the editing of *The World at War*. The juries of the SFTA at this time were dominated by the BBC and perhaps the wound of being pipped to the post by Thames in making a World War II series still rankled. The SFTA, possibly feeling bad that the series that had won almost everything else but one of their awards, dedicated an entire issue of their journal to the making of *The World at War* instead.[165]

In a recent study, James Chapman has analysed the letters sent in to Thames during and after the transmission of the series.[166] There were many letters of congratulation as might be expected. But there were a large number of critical letters as well, suggesting that much of the historical memory captured was deeply contested. Some viewers found the series too pro-American. Some American viewers found it too pro-British. More seriously, Polish communities in Britain and the US were offended by the failure to feature the destruction of Poland and by the underrepresentation of Polish campaigns later in the war. Jeremy Isaacs recognised this criticism and it was one reason why, ten years later when he was running Channel 4, he commissioned Martin Smith to produce a nine-part series called *The Struggles for Poland* (1985). He wanted to make up for the omission in *The World at War*.[167]

For forty years *The World at War* has never been off television screens somewhere. It has been sold to more than fifty countries around the world, including Germany, Japan and Italy. In the United States for forty years, as one six-month period of transmission ended, another began. The series has been extremely popular on channel like the Arts and Entertainment Network (A&E) and from the mid-90s on the History Channel, a subsidiary of A&E. In Britain, it was repeated on Sunday afternoons on ITV soon after its first run concluded. It was then shown again on terrestrial television on Channel 4 in 1983 and on BBC2

in 2002. In the digital, cable and satellite universe it is constantly being shown by either the History, Yesterday, Discovery or National Geographic channels each of which regularly competes to outbid its rivals to buy the next period of exclusive rights from the current owners, Fremantle Media. Several VHS and then DVD versions have been produced including a thirtieth anniversary Limited Edition set and a hi-definition digitally restored and remastered DVD and Blu-ray set known as the Ultimate Restored Edition. Rumour has it that preparing this latest version in 2010 cost more than the budget for the original series in 1971.

At the time of its first broadcast, Thames gave the final cost of *The World at War* at just under £1 million. In other words the series had cost double its original budget. But no one seemed to mind. The series had achieved its objectives. It had won extensive critical praise for Thames and for ITV. The Independent Broadcasting Authority referred to the series frequently as an indicator of the highest-quality public-service programming that the ITV network was capable of. In the ITV companies' evidence to the Annan Committee later in the 1970s, *The World at War* was one of the programmes cited at length in presenting the case that the fourth channel should become ITV2.[168] In addition to all these 'brownie points' and the prestige they created, the series sold extremely well abroad, earning considerable sums for the overseas selling arm of Thames that in 1974 became Thames Television International (TTI). Earnings for TTI stood at £1.3 million in 1974–5 and trebled in the next five years.[169] Over the years the series has earned literally millions of pounds in international earnings. The IWM continues to receive its 5 per cent share of all international sales. The most conservative estimate would put the figure of total overseas earnings from *The World at War* at about £5 million. Added to this are the sales revenues for all the UK repeats and DVD versions. In all this is equivalent to tens of millions of pounds in today's terms.[170]

As a consequence of the enormous success of *The World at War*, Thames and particularly Thames Television International were keen to get more programming from the team under the same brand. As

152

so much interview material had been shot and so much archive footage duplicated, there were abundant opportunities to make some spin-offs. So several Specials were put together in the year following completion of the main series. This was not only a chance to make productive use of the outtakes, but also an opportunity for some of the team members to make their own programmes. Sue McConachy produced a programme about Traudl Junge using much more of her interview than had featured in the series, called *Secretary to Hitler* (1976). Raye Farr produced two one-hour films called *Hitler's Germany* (1975), written by Jerry Kuehl. Alan Afriat edited and produced a film using comments from interviewees about the experience of combat, called *Warrior* (1975). Martin Smith produced a film about the mysteries surrounding Hitler's death called *The Two Deaths of Adolf Hitler* (1975). All of these spin-offs were made quite cheaply as the content had already been gathered and the extra hours of material reduced the cost per hour of the total output under *The World at War* brand. And, of course, the Specials provided more programming for Thames to sell profitably abroad.

Michael Darlow and his editor on 'Genocide', Peter Lee-Thompson, had started working in the evenings to create a longer version of the Holocaust film as they were so aware of the historical importance of their material and how much they had not been able to show in the single fifty-two-minute episode. This then became one of the additional Specials, an extraordinarily powerful three-hour film called *The Final Solution* (1975). Featuring extended interview material and some additional archive footage, *The Final Solution* was shown as two ninety-minute films after *News at Ten* in the UK. In the US some stations showed it in its full 180-minute version without commercial breaks.

The making of *The World at War* coincided with and helped to influence the changing relationship between historians and film. A. J. P. Taylor had said provocatively of the BBC's *The Great War* series at a conference in 1968:

> Any of you seeing 'compilations' made by non-historians will, I am sure, know that few serious standards of scholarship are observed … . I for one

153

sat with great discomfort through such programmes as the BBC's 'First World War'. It was a monstrous use, I thought, of historical material in order to create effects. A very nice thing to do but not what we historians want.[171]

However, in the late 1960s several developments prompted academic historians to think more seriously about film and its use on TV. The Inter-University History Film Consortium was encouraging historians to make their own films, and historians like John Grenville in Birmingham and Nicholas Pronay at Leeds were pioneering the historical study of film as evidence. Arthur Marwick at the Open University was also using film as source material in the television shows that were an essential part of the study material for OU courses. At the Slade a History Film Register, set up by legendary British film-maker Thorold Dickinson, listed and catalogued newsreels, documentaries and other non-fiction film. And the British Universities Film and Video Council was also encouraging the more serious study of film within history. The Imperial War Museum was at the centre of these developments. Christopher Roads (the Deputy Director who negotiated the IWM deal with Thames in 1971) had given a speech on 'Film as Historical Evidence' in December 1965.[172] When Clive Coultass joined the museum in 1969 he was asked by Noble Frankland to find 'new directions' to better exploit the collection.[173] A series of conferences took place at the IWM including 'Archive Film in the Study and Teaching of Twentieth Century History' (June 1972) and 'Film Propaganda and the Historian' (July 1973) to promote the serious assessment of film by historians.

This academic debate was happening simultaneously with the production of The World at War and members of the team like Jerry Kuehl kept in close touch with these developments. This was the broader context within which the team wanted to use archive film as authentically as possible and break away from the cavalier manner in which it had been employed in earlier TV series like The Great War. Kuehl insisted that it would not do to take the attitude that 'one Stuka looks just like another'. He argued that programme makers should feature a clip of film only if they knew that it accurately represented

what they claimed it represented. If a viewer cannot believe in the authentic use of the visual material in a Television History documentary, Kuehl argued, then why should he or she believe that anything else in the programme is correct? Isaacs largely agreed with this approach as did most of the directors of the series. But Kuehl still made himself unpopular with some of the film-makers by arguing this so rigorously. Ted Childs felt the wrath of a Kuehl memo in making 'Wolfpack' because there was so little genuine footage of the Battle of the Atlantic. This episode had to rely on staged material or training film. But Kuehl wrote of the rough cut, 'I was surprised to see the same clip of a submarine sinking at two points in the film.'[174] Michael Darlow thought Kuehl's objection to the use of the killing footage in 'Genocide' was absurd. As there was so little footage of mass killings taking place, for obvious reasons, he thought he was quite justified in using the rare footage in a generic way. Kuehl disagreed and argued that even in this context the film should be used as accurately as possible and only to depict events described in the commentary. The two came near to falling out over this.[175] The debate continues today between the purist school and the 'this tank looks just like that tank' approach.

155

Certainly one of the great achievements of the series was to reach a new standard for the accurate inclusion of archival material on television and this was recognised by historians and serious critics alike. Arthur Marwick claimed that *The World at War* 'set new standards for prodigious research and integrity of presentation'. He argued that documentaries are 'more valuable as history to the extent to which they adhere to this basic principle that visual programmes should ... [avoid] irrelevant wallpaper or unidentified visual material'.[176] Penelope Houston wrote that *The World at War* 'is good television, driving forward every week, building up personality as a series'. She went on to praise the production team for their use of archival film and for the interrogation of its use, concluding 'The average viewer is not trained to sift visual evidence ... [but] *The World at War* team [have] obviously asked a great many questions about their own material.'[177]

An Army Film Unit team in the field. By the 1970s historians were beginning to accept film as a form of historical evidence

So how can *The World at War* be judged today? First as history, the series suffers from many serious omissions. We have seen how the Poles were aggrieved that their story barely gets a look-in. Episode 2, 'A Distant War', tells the events of 1939–40 entirely from an Anglo-French perspective. However, the destruction of Poland was not 'distant' from the perspective of Warsaw. There is no treatment of China in the series apart from a brief recap of the Japanese incursions before Pearl Harbor, in episode 6, 'Banzai!'. Again, this is a reflection of the fact that Mao's China, still reeling from the Cultural Revolution of the late 1960s, was entirely closed to programme makers when *The World at War* was made. There is also no mention of Yugoslavia in the war and how Tito, armed by the British, emerged powerful enough to

rule the country after the war. Bearing in mind the consequences of the break-up of the Yugoslav state in the 1990s, it is difficult to imagine any serious history of the war made in recent years ignoring Yugoslavia. But *The World at War* (like all history) is the product of its time and, for instance, it dwells on Southeast Asia in episode 25, 'Reckoning', where the war in Vietnam was still fighting its way to a messy conclusion when the series was being made, in a way that few film-makers would today.

More serious is the problem that the series became out of date almost immediately. Within weeks of the transmission of the last episode Frederick Winterbotham published *Ultra at War* (1974), making the first revelations about the extraordinary code-breaking achievements at Bletchley Park. Over the following years the full story of how British Intelligence deciphered high-level German military and some civil communications led to a rewriting of much of the military history of the war. *The World at War* was finished before any of this came to light. The programme on the Battle of the Atlantic, 'Wolfpack', is probably the episode most affected, as Bletchley Park played a central role in tracking down the locations of the U-boats and in turning the war in the Atlantic in the spring of 1943. Ultra decrypts were also crucial in identifying the sailing of Afrika Korps supply convoys from Italy to North Africa enabling them to be attacked; and in the battle for Crete.

157

Until the early 1970s, sources for historians writing about World War II were limited to the official histories produced under the aegis of the Cabinet Office, or to the many memoirs that had been published, invariably promoting their authors' roles in the events described. Through Noble Frankland as principal historical adviser, the team received the most up-to-date summary of how the military strategies of the war had unfolded. However, the 1967 Public Records Act introduced a new Thirty Year Rule for the release of public records so that from 1972 more and more material on the war began to be released in bulk for historians to pore over. This explosion in the availability of primary sources about World War II has given historians an immense amount of meat to feed on. Indeed, it has kept the writing of

wartime histories a lively concern up to today. But nearly all the discoveries and the 'finds' were published after *The World at War* was completed. Despite this, very few viewers or critics seem concerned that almost from the moment of its completion parts of the history behind the series were obsolete. And teachers in schools and universities all around the world still use the series as an introduction to studying the war.

More broadly, however, *The World at War*, along with many other Television History series like *The Great War* before it and *The Nazis – A Warning from History* (2003) and other Lawrence Rees series after it, have helped to raise the status of oral history. Historians were prompted to re-evaluate the sort of records left by 'ordinary people', including their letters, diaries and other personal records. Recent years have seen a massive increase in the writing of a bottom-up view of history. This has become very popular in writing about World War I in the books of, for instance, Lyn Macdonald and Malcolm Brown, and in the series of books under the *Forgotten Voices* brand by Max Arthur and others.[178] And in his studies of post-war Britain, David Kynaston has provided a marvellously human perspective on an era of vast social and economic change by drawing extensively upon personal accounts.[179] There are few historical subjects in which historians today would not value the views of the ordinary citizen. In his history of World War II entitled *All Hell Let Loose: The World at War, 1939–45* (2011), Max Hastings foregrounded the evidence from individual witnesses. Reviewers were quick to praise this approach. In the *Guardian* Philip Hensher wrote:

> It's the significance of the individual witness that powers Max Hastings' new history … . What is new and interesting here is the reliance on people who simply set out their own observations … Hastings' plan is to revitalise the sense of suffering and bravery by exploiting first person accounts from every theatre of this vast war.

In the *Observer* Ian Thomson asked:

158

> But how to make a familiar subject new? Hastings has chosen to write
> an 'everyman's story' which concentrates on ordinary human experience
> instead of warlords and campaign derring-do. Much of the book is made
> of eyewitness accounts provided by 'little people' …[180]

Exactly the same could be said of the objective of *The World at War*
nearly forty years earlier.

I have heard many reasons for the enduring success of *The
World at War* in talking to those who made the series. That it was down
to the power of the interviewees, the strength of the archive, the appeal
of the war. Or the quality of Carl Davis's music, the power of Olivier's
delivery or the strength of the writing. It has been said that watching
the series is like sitting around a camp fire learning from the stories of
others. That its success is down to the perfectionism of dedicated
television professionals. And everyone I interviewed for this book said
how important *The World at War* was to their own careers. David
Elstein said it was creatively the most important thing he had ever done
– and he went on to edit *This Week* for four years, became Director of
Programmes at Thames, then Head of Programming at BSkyB and Chief
Executive of Five for its launch. Neal Ascherson said that *The World
at War* was the most important journalistic enterprise he was ever
connected with. Raye Farr said it was the culmination of her
professional work and marks a direct line to her current employment at
the Holocaust Memorial Museum in Washington. Alan Afriat said that,
if anyone ever asks him if his life has been worthwhile, he can always
reply that he worked on *The World at War*. Martin Smith said simply
that it made his career.

Jeremy Isaacs, unsurprisingly, admits to being 'immensely
proud' of *The World at War*. By the time the series had finished its
first transmission, Isaacs had been promoted from Head of Features to
Director of Programmes at Thames, the first time a factual programme
maker had reached the top echelons of an ITV company. *The World at
War* helped to make him one of the most famous television executives in
Britain. In 1981 when the government was looking for a Chief Executive

159

to launch the new fourth channel Isaacs was selected. This brought him into the public limelight even more. After failing to be appointed Director-General of the BBC by the governors in 1987 (the final revenge of the BBC?), Isaacs left television to become General Director of the Royal Opera House, Covent Garden. He returned to television in the mid-1990s, lured back by American television mogul Ted Turner. Turner was a great fan of *The World at War* and wanted the producer of that series to make his new project on the history of the Cold War. Isaacs eventually agreed and through his own company, Jeremy Isaacs Productions, assembled a team of eighty-five people who spent three years making *Cold War* from 1995 to 1998. *The World at War* in many ways provided the template for the new history series except in one respect. Turner wanted forty episodes. Isaacs proposed twenty. They eventually compromised on twenty-four. Isaacs could not bear to produce a series of twenty-six episodes again.[181]

My own view is that the enduring success of *The World at War* is partly down to its ambition and its scale is unknown today in the more fractured world of broadcasting. It takes on the global experience of the war and makes the viewer feel that it is delivering on this. It needed a wealthy television production company, Thames, with corporate ambitions to show that it could produce high-quality programming in order to raise its profile, to compete with the BBC and prove that ITV could take on the fourth channel when it arrived. Large series like these need wealthy backers and for at least twenty years they have been hard to find in factual television.[182] The series also succeeds because the overall plan drawn up by Jeremy Isaacs in the spring of 1971 was kept to, and it worked. Watching the episodes gives the sense of slowly progressing through the chronology of the war. Chronology helps a lot when it comes to narrative history. But it is also possible to miss episodes without losing the plot. Viewers can drop in and out of the series and pick up on the progress of the war without feeling they have missed something vital. Each episode is a self-contained chunk of history in its own right and works as a stand-alone programme. So the viewer can take all or just parts of the series. This is a huge measure of its

accessibility today when few people are likely to make an appointment at the same time each week to watch twenty-six episodes of a factual series. Indeed, often when *The World at War* has been transmitted in recent years it is shown not across twenty-six weeks but over a weekend or even a twenty-four-hour period in a themed event as a television stunt, a sign of how viewers approach a series on this scale in a very different way today to forty years ago.

In addition, although parts of the series look dated, with the omission of the Bletchley Park code breakers, the failure to cover China, the mannered delivery of Laurence Olivier and the degraded portrait of the interviewee's face every time a name caption comes up, the series as a whole still has a freshness to it. This is down to the strength of the storytelling and the power of the narrative. As has been argued, although in one sense this is a narrative that forces itself on the viewer as *the* account of World War II, it is not a single-tracked narrative and it does allow for different interpretations and different understandings of the same event, like the reaction of the German people to the fate of the Jews in 'Inside the Reich', or the treatment of propaganda film in 'Stalingrad'. It would be better to describe *The World at War* as having a *layered narrative* that allows for different reactions to different moments, like Anthony Eden's reaction to the news about the existence of the extermination camps in 'Genocide', or Albert Speer's account of regretting not having confronted Hitler with accusations of what was happening in the East.

The other characteristic that still makes *The World at War* stand out four decades after its production is that it freely encompasses different styles of film-making. The series in many senses has a distinct unity to it, each programme begins with a Tease and features the very distinctive Titles, while Carl Davis's music and Olivier's commentary are constant throughout. But Jeremy Isaacs did not impose a rigid style of film-making on his directors. Peter Batty's six programmes mostly concentrate on military strategy and the thoughts of commanders and senior officers. Michael Darlow's two episodes, 'Occupation' and 'Genocide' work mostly through the strength of their eye-witness

testimony and the moral questions they raise. Martin Smith's episode 'Red Star' really positions itself from the perspective of the Russian people. David Elstein's 'The Bomb' is an historical film essay about the context of the decision to drop the atom bomb, packed with testimony from leading participants in that decision. 'Stalingrad', on the other hand, has no interviewees at all. 'Reckoning' and 'Remember' stand back and take a more considered look at the winners and losers and explore how it is possible to memorialise an event on the scale of World War II. Isaacs had the confidence in making the series to allow different approaches but to contain all of the diversity within one framework. Again, it is almost impossible to find this type of confidence among commissioning editors or channel controllers today. They are nervous of variations to the agreed style. Inconsistency is regarded as a sign of weakness. As a consequence many Television Histories and other factual series are produced today within a straitjacket that insists on and imposes a unity of approach. The form has come to dominate the content in a great deal of contemporary television. Format is king.

162

It has been said many times that *The World at War* was a child of its times – the eye-witnesses were of an age to want to talk about what they had seen and experienced; Thames was a wealthy and ambitious company keen to demonstrate that ITV could make quality public-service programming; even the problems of access to the Soviet Union and the lack of access to China were signs of the time. But in another sense *The World at War* was made at a time when historians, journalists and film-makers were beginning to consider the moral ambiguities of war. For three decades after 1945 most films of the war were of the heroic brand, boy's own stories of drama and derring-do. But at the end of the 1960s and in the early 70s this began to change. Several years of war in Vietnam not only generated an anti-war movement but also engendered a greater sense of the moral ambiguity of war. This is clearly reflected in some of the movies made at about this time. In 1968 John Wayne presented Vietnam in the patriotic posturing of *The Green Berets*. A decade later a much darker view of Vietnam emerged from *The Deer Hunter* (1978) and *Apocalypse Now* (1979). Somewhere in

between a great change had taken place. If there was a single turning point it was probably in 1970 when the movie of Joseph Heller's *Catch 22* was released. Now war was not only bad but also mad. The moral environment in which war was both portrayed and understood began to change. There was an examination of both the horrors of war and of the moral predicaments thrown up by war. This moral ambiguity pervades much of *The World at War*. Several episodes explore the options confronting individuals at different moments of the war. In 'Inside the Reich' this relates to the choices housewives have to make about taking in Jewish refugees or making a stand in the shopping queue about reported atrocities. In 'Occupation' it relates to the choices made by Dutch civilians as to whether to co-operate with, collaborate or resist the occupier. In 'Whirlwind' it relates to the desire for revenge on those who had 'sown the wind' in the bombing of Rotterdam, London and Coventry. Certainly there is an overall sense that this was a just war that had to be fought. As Stephen Ambrose says at the end of 'Reckoning', with the defeat of Nazism in Germany, militarism in Japan and fascism in Italy, 'justice had never been better served'. But *The World at War* is definitely not a series about good guys and bad guys.

163

World War II has retained a positive image in the popular culture of Britain and America because of the widespread feeling that it was a war that it was right to fight. And because of the equally strong feeling that it was a war that can justly be celebrated because unequivocally *we won it*. But that is not what comes out of *The World at War*. It still records the justice of the Allied cause but does not celebrate the war and it most certainly does not cheer the Allied victory. There are certainly programmes that deal with the courage of fighting men and the sacrifice of citizens, sometimes, as in Russia, on a vast scale. There are many stories of how war draws out the best and worst in individuals, prompting small acts of heroism and enormous deeds of violence. But over and above this, from the opening sequence of Oradour-sur-Glane in the first episode, to the reflections on remembrance in the last, *The World at War* is full of stories about moral challenges.

It was noted in the brief opening chapter that the series was made at a time of national doubt and self-questioning in the early 1970s when many of the principles of the post-war world were being challenged. But that does not mean that *The World at War* dwelt on the glories of the war in order to mask or provide an escape from the failures of the present. Had it done so, the series would have been popular for a year or two and then forgotten. Its unique and enduring popularity is down to the fact that it does not take sides, it does not generate a feel-good factor. It shows war and describes conflicts and atrocities in all their horror. It is far superior to most Television History for that. Although in many ways it gets more out of date as each year passes, *The World at War* will probably still be as popular in forty years time as it is today, forty years after it was made.

Notes

1 Dominic Sandbrook, *State of Emergency*, p. 9.

2 Michael Young and Peter Wilmott, *The Symmetrical Family*, pp. 212, 216.

3 The coronation of 1953 was a huge boost to the infant television industry, and retailers used the upcoming royal wedding of 1973 to promote the sale of colour television sets.

4 Sandbrook, *State of Emergency*, p. 46.

5 The principal history of the cinema compilation film with detailed analyses of these and many other films is Jay Leyda's *Films Beget Films*. It is interesting to note that this book by the leading film historian was published in 1964, the year in which television compilation films really took over from those made for cinema distribution.

6 Robert Dillon, *History on British Television*, pp. 37 and 54ff.

7 Taylor Downing 'Screen Saviours'.

8 Adam Sisman, *A. J. P. Taylor*, p. 264.

9 Stefan Collini, *Absent Minds*, pp. 380–1.

10 Simon Schama in interview with Mark Lawson accompanying the boxed DVD set of *A History of Britain*.

11 Jonathan Conlin, *Civilisation*, p. 5

12 Dillon, *History on British Television*, p. 140.

13 See J. A. Ramsden, 'The Great War'; also Taylor Downing 'The Great War'.

14 Jeremy Isaacs, *Look Me in the Eye*, pp. 2–10.

15 The most senior executive to move from ITV to BBC was the Canadian Sydney Newman who had run *Armchair Theatre* (1956–74) at ABC Television. After being lured to the BBC, it was his clear vision of contemporary drama that led to the creation of such pioneering BBC series as *The Wednesday Play* (1964–70), *Z-Cars* (1962–78) and *Doctor Who* (1963–). See Isaacs, *Look Me in the Eye*, pp. 58–89.

16 Isaacs, *Look Me in the Eye*, pp. 88–118 and Jeremy Isaacs interview with the author, 9 December 2011.

17 Jeremy Potter, *Independent Television in Britain Vol. 3*, p. 2.

18 Concerned by the scale of the losses in the early days in setting up the ITV system, Associated Newspapers, publishers of the *Daily Mail*, sold its stake in Associated-Rediffusion and in 1964 the company was rebranded simply as Rediffusion.

19 Isaacs, *Look Me in the Eye*, p. 126 and Isaacs interview with the author, 9 December 2011.

20 Potter, *Independent Television in Britain Vol. 4*, p. 57.

21 Peter Batty interview with the author, 16 December 2011.

22 *Listener*, 1 May 1969, p. 595.

23 *Listener*, 8 May 1969, p. 651.

24 Isaacs, *Look Me in the Eye*, p. 149 and Isaacs interview with the author, 9 December 2011.

25 Peter Morley, *A Life Rewound*, p. 138.

26 Batty interview with the author, 16 December 2011.

27 Batty Papers: letter PB to Brian Tesler, 9 January 1970.

28 Batty Papers: letter and proposal PB to Jeremy Isaacs, 14 February 1970.

29 Batty Papers: letter Brian Tesler to PB, 12 May 1970.

30 Isaacs interview with the author, 9 December 2011.

31 *Thames Television Annual Report – The First Year*, published October 1969. In his Chairman's Statement Shawcross wrote that when he took over the chairmanship of Thames he shared the prevalent attitude that 'Independent Television was making vast profits' but that he could not have 'been more wrong'. He argued that Parliament 'ought to know better' and that ITV was in a parlous situation because of the huge sum paid to government through the Levy that defied the principles of 'normal taxation'. He concluded that 'The return [on investment] is at present totally inadequate' and unless there was a 'prompt and drastic revision of the way in which the Levy is charged, so as to enable the companies to retain sufficient income to meet the inevitably increasing programme costs and to provide a fair return on capital invested' then programme quality would deteriorate as the 1970s advanced. Shawcross pulled no punches in this powerful outburst.

32 'By the Financial Editor', *The Times*, 16 February 1971, p. 16.

33 Isaacs Papers: letter from Derrick Amoore to JI, 8 February 1971.

34 Batty Papers: Personal Memoir: Batty had met Derrick Amoore again on 1 January 1971 for lunch at Parkes on Beauchamp Place.

35 Isaacs interview with the author, 9 December 2011.

36 Isaacs interview with the author, 9 December 2011.

37 The Imperial War Museum film archive is the oldest in the country and goes back to the establishment of the museum in 1917, predating the establishment of the BFI National Film Archive in 1935.

38 Noble Frankland, *History at War*, p. 182.

39 Ibid., p. 188.

40 Ibid., p. 189 and Noble Frankland interview with the author, 30 January 2012.

41 Isaacs, *Look Me in the Eye*, p. 150 and Isaacs interview with the author, 9 December 2011.

42 Comparisons are calculated via www.measuringworth.com according to the Retail Prices Index.

43 IWM: Frankland Papers: F4/5: letter Jeremy Isaacs to NF, 16 March 1971.

44 IWM: Frankland Papers: F4/5: letter NF to Jeremy Isaacs to NF, 23 March 1971.

45 Roy English interview with the author, 20 September 2011.

46 *The Times*, 1 April 1971.

47 Morley, *A Life Rewound*, p. 139.

48 Isaacs interview with the author, 9 December 2011.

49 IWM: Frankland Papers: F 4/5: Letter and attachment Jeremy Isaacs to NF, 28 April 1971.

50 Isaacs interview with the author, 9 December 2011.

51 See Isaacs, *Look Me in the Eye*, pp. 378–80 and Downing, 'History on Television', pp. 329–30. The *Cold War* series of course covered world history across a period of forty-five years.

52 This document was widely copied and it survives in many collections including IWM: Film Papers: LOC 535. Isaacs's accompanying letter is in IWM: Frankland Papers: F 4/5: handwritten letter Jeremy Isaacs to NF, 21 May 1971.

53 IWM: Frankland Papers: F 4/5: letter NF to Jeremy Isaacs, 1 June 1971.

54 In the event, Frankland was offered an additional sum of £500 in 1973 when the series was taking longer to complete than had been initially imagined.

55 In addition to film and photographs, this included the collections of documents, art and possibly even exhibits.

56 IWM: Museum Archives: World at War: Letter summarising the decisions reached

at the meeting on 11 May, by Jeremy Isaacs to Noble Frankland, 13 May 1971.

57 IWM: Museum Archives: World at War: Letter summarising the decisions reached at the meeting on 23 May, by Jeremy Isaacs to Noble Frankland, 25 May 1971.

58 Ibid.

59 These interviews formed the basis of the book *The World at War* edited by Richard Holmes and published in 2007.

60 IWM: Museum Archives: World at War: Letter Noble Frankland to Jeremy Isaacs, 2 June 1971.

61 IWM: Museum Archives: World at War: Handwritten memo from Jonathan Chadwick to Christopher Roads, 5 August 1971.

62 IWM: Museum Archives: World at War: Letter Christopher Roads to Treasury Solicitor, 9 August 1971.

63 IWM: Museum Archives: World at War: Letter Treasury Solicitor to Christopher Roads, 13 August 1971.

64 Ibid.

65 Isaacs interview with the author, 9 December 2011; the quotes that follow are also from this interview.

66 The classic example of this is Ken Loach and *Cathy Come Home* (first TX: BBC1 16 November 1966); see Stephen Lacey, *Cathy Come Home*, pp. 17–22.

67 Isaacs, *Look Me in the Eye*, p. 73.

68 For instance, Jeremy Isaacs, 'All Our Yesterdays', in David Cannadine (ed.), *History and the Media*, pp. 34–50.

69 David Elstein, 'Directing the World at War', p. 10.

70 See, for instance, Dillon, *History on British Television*; Colin McArthur, *Television and History*; Simon Schama, 'Television and the Trouble with History', in David Cannadine (ed.), *History and the Media* and Tom Stearn, 'What's Wrong with Television History'.

71 Isaacs interview with the author, 9 December 2011 and Elstein, 'Directing the World at War', pp. 10–11.

72 Jerome Kuehl, 'History on the Public Screen,' in Paul Smith (ed.), *The Historian and Film*, p. 182.

73 Isaacs interview with the author, 9 December 2011.

74 A Thames TV film production team in 1971 would have consisted of at least eight people: the director, a cameraman, an assistant cameraman, a sound recordist, an assistant sound recordist, a production assistant (all ACTT grades), an electrician (an ETU grade) and a driver/rigger (a NATTKE grade). The researcher (also ACTT) would almost certainly have been present but this was not a union requirement.

75 Isaacs interview with the author, 9 December 2011.

76 A lot of talented production people left staff jobs to go freelance because as long as the jobs kept coming in it was possible to make more money as a freelancer.

77 Liz Sutherland interview with the author, 11 August 2011.

78 John Rowe interview with the author, 9 November 2011.

79 IWM: Film Dept Records: LOC 550: Folder of correspondence by John Rowe.

80 Raye Farr interview with author, 11 February 2012.

81 Alan Afriat interview with author, 14 February 2012.

82 Isaacs interview with the author, 9 December 2011.

83 Most interviewees were recorded singly but some were interviewed in groups, like East End survivors of the Blitz or Dutch civilians remembering the Nazi occupation, so the total number of people who sat in front of the cameras is nearer to 400, see IWM Department of Sound

167

Records pamphlet *The World at War* (undated), p. 3.

84 IWM: Film Dept Records: LOC 550: Memo from Jerry Kuehl to Jeremy Isaacs, 12 March 1972.

85 Kuehl interview with the author, 7 February 2012.

86 Thames made a distinction between film researchers (like John Rowe and Raye Farr) who found and copied archive film, and programme researchers (like Sue McConachy and Isobel Hinshelwood) who found interviewees, still photographs and fulfilled all other roles in support of documentary production.

87 Sue McConachy died in 2006 but has written and been interviewed about her work on *The World at War*. See Susan McConachy, 'Researching the World at War', *Journal of the Society of Film and Television Arts* vol. 2 nos 9–10, 1974, p. 6 (the issues dedicated to *The World at War*).

88 Interview with Susan McConachy in *Cineaste* vol. 9 no. 2, Winter 1978–9, p. 24.

89 McConachy 'Researching the World at War', p. 7.

90 Martin Smith interview with the author, 22 January 2012.

91 Isaacs interview with the author, 9 December 2011.

92 McConachy, 'Researching the World at War', p. 6.

93 Isaacs interview with the author, 9 December 2011.

94 Tony Bulley interview with the author, 19 March 2012.

95 Davis interview with the author, 8 November 2011.

96 Carl Davis, 'Composing the Music for World at War', *Journal of the Society of Film and Television Arts* vol. 2 nos 9–10, 1974, p. 24 (the issues dedicated to *The World at War*).

97 Isaacs interview with the author, 9 December 2011.

98 Bulley interview with the author, 19 March 2012.

99 Some of the metal plates that were used for the graphics still exist and are preserved by the Art Department of the Imperial War Museum.

100 Isaacs, *Look Me in the Eye*, p. 157.

101 Isaacs interview with the author, 9 December 2011.

102 Sutherland interview with the author, 28 March 2012.

103 Isaacs interview with the author, 9 December 2011.

104 Isaacs, *Look Me in the Eye*, p. 172; Isaacs interview with the author, 9 December 2011; Peter Batty interview with the author, 16 December 2011.

105 Isaacs, *Look Me in the Eye*, p. 172.

106 Ibid., p. 173 and Isaacs interview with the author, 9 December 2011.

107 Isaacs interview with the author, 9 December 2011. These comments were made several years later in 1978 when Olivier declined a request to record the commentaries for Thames Television's thirteen-part history of the silent cinema, *Hollywood*.

108 Isaacs interview with the author, 9 December 2011.

109 For instance in McArthur, *Television and History*, pp. 21–6.

110 Neal Ascherson interview with the author, 7 February 2012.

111 Isaacs interview with the author, 9 December 2011.

112 Farr interview with the author, 11 February 2011.

113 IWM: Film Dept Records: LOC550: Memo Jeremy Isaacs to 'All Second World War Personnel,' 2 March 1972.

114 Smith interview with the author, 22 January 2012.

115 Whitehead had been at the BBC from 1961–7 and was the first editor of *This Week* at Thames from 1968–70. When he was elected to Parliament in 1970 he resigned as editor of the weekly current-affairs slot but kept up his interest in producing TV programmes. He died in 2005.

116 Farr interview with the author, 11 February 2012.

117 Batty Papers: Biographical Note.

118 Each editor also worked with an assistant editor who helped to log and supply the film to the editor and supported the cutting process in countless ways.

119 Alan Afriat described the whole process in 'Film Editing the World at War', *Journal of the Society of Film and Television Arts* vol. 2, nos 9–10, 1974, pp. 16–21 (the issues dedicated to *The World at War*).

120 Afriat interview with the author, 14 February 2012.

121 Ascherson interview with the author, 7 February 2012.

122 *The World at War* was made before VHS cassettes were available and so the writers and also Carl Davis in composing the music, had to work at a Steenbeck where precise timings could be taken and words and music read or played direct to the picture. From about ten years later it was common for writers and composers to take copies of programme rough cuts away with them on VHS to work on at home or in a studio.

123 Anne Fleming interview with the author, 31 January 2012.

124 Farr interview with the author, 11 February 2012.

125 Ascherson interview with the author, 7 February 2012.

126 IWM: Frankland Papers: F4/5 contains all his viewing notes.

127 IWM: Frankland Papers: F4/5: notes by NF to Isaacs, 18 October 1972.

128 IWM: Frankland Papers: F4/5: letter Isaacs to NF, 22 November 1972.

129 IWM: Frankland Papers: F4/5: letter NF to Isaacs, 3 December 1972.

130 IWM: Frankland Papers: F4/5: letter Isaacs to NF, 12 December 1972.

131 IWM: Frankland Papers: F4/5: letter NF to John Hambley, 17 March 1972.

132 See the 'Introduction' to the 2001 edition of the book by Richard Overy, pp. ix ff.

133 Isaacs interview with the author, 10 December 2011.

134 IWM: Frankland Papers: F4/5: Working Treatment by JI, May 1971.

135 Lutz Becker interview with the author, 6 March 2012.

136 Kuehl interview with the author, 7 February 2012.

137 Isaacs interview with the author, 9 December 2011 and Ascherson interview with the author, 7 February 2012.

138 Farr interview with the author, 11 February 2012; Afriat interview with the author, 14 February 2012.

139 Not only had Batty made several programmes about World War II before *The World at War* (see Chapter 4) but he also wrote and has continued to write military history, for instance in 2011 he published *Hoodwinking Churchill – Tito's Great Confidence Trick* about Tito's war of 'liberation' in Yugoslavia.

140 Field Marshal Montgomery was still alive when the series was made but was not well and declined to be interviewed, probably a wise decision as the Monty myth was too important to risk it being devalued by an interview revealing an old man with a fading memory.

141 Kuehl interview with the author, 7 February 2012.

142 Ibid.

143 Smith interview with the author, 22 January 2012.

144 Ibid.

145 David Elstein interview with the author, 8 November 2011.

146 IWM: Frankland Papers: F4/5: letter and Treatment from Isaacs to NF, 28 April 1971.

147 Darlow Papers: Death Camps, 'Argument for a Film about Nazi Concentration Camps', 30 August 1972, p. 1.

148 Michael Darlow, 'Baggage and Responsibility: The World at War and the Holocaust', in Toby Haggith and Joanna Newman (eds), *Holocaust and the Moving Image*, p. 142.

149 Darlow Papers: Death Camps, p. 41.

150 Michael Darlow interview with the author, 21 February 2012.

151 Darlow Papers: Death Camps, p. 40.

152 Darlow interview with the author, 21 February 2012.

153 Interview with Susan McConachy in *Cineaste*, p. 24.

154 Darlow interview with the author, 21 February 2012.

155 Ibid.

156 Interview with Susan McConachy in *Cineaste*, p. 25.

157 Farr interview with the author, 11 February 2012 – Farr is referring to recommendations given by the Holocaust Memorial Museum in Washington DC where she works.

158 *Guardian*, 28 March 1974; *Daily Mirror*, 28 March 1974; *Sunday Times*, 31 March 1974; *Daily Telegraph*, 28 March 1974.

159 Quoted with the press reviews in James Chapman 'Television and History'.

160 Darlow Papers: Letter Mary Whitehouse to Thames Television, 30 April 1974.

161 Farr interview with the author, 11 February 2012.

162 Kuehl interview with the author, 7 February 2012.

163 Stephen Ambrose's career was much later marred by charges of plagiarism, but at this point he was a young historian who had written biographies of Eisenhower and Nixon and was highly regarded in the US.

164 *Financial Times*, 3 November 1973; *Observer*, 11 November 1973, *Daily Telegraph*, 9 May 1974; *Daily Express*, 9 May 1974; *Baltimore Sun*, 9 August 1975.

165 *Journal of the Society of Film and Television Arts*, dedicated issues.

166 James Chapman, 'Television and History'.

167 Isaacs interview with the author, 9 December 2011.

168 Potter, *Independent Television in Britain*, vol. 3, pp. 29, 234–6.

169 Potter, *Independent Television in Britain*, vol. 4, p. 66; TTI was enormously successful in selling not only *The World at War* but also a host of other Thames programmes from *Bless This House* (1976–9) to *George and Mildred* (1976–9). The programme that attracted the highest sales of all was *The Benny Hill Show*.

170 It's difficult to give a 2012 equivalent of these sums as they have been received over such a long period but it is certainly equivalent to tens of millions of pounds earned in total in today's money.

171 British Universities Film Council, *Film and the Historian*, p. 1.

172 Christopher Roads, 'Film as Historical Evidence'.

173 Coultass interview with the author, 13 February 2012.

174 IWM: Film Dept Papers: LOC 550: Memo JK to Jeremy Isaacs, 12 March 1972.

175 Kuehl interview with the author, 7 February 2012; Darlow interview with the author, 21 February 2012.

176 Arthur Marwick, *The Nature of History*, pp. 315, 235.

177 Penelope Houston, 'Witnesses of War'.

178 Examples of some of these works include Lyn Macdonald, *Somme* (1983) and *They Called It Passchendaele* (1993); Malcolm Brown, *The Imperial War Museum Book of the Somme* (1996) and *Tommy Goes to War* (1999); and Max Arthur, *Forgotten Voices of the Great War* (2002).

179 For example in the several volumes of *Tales of a New Jerusalem* including *Austerity Britain 1945–1951* (2007) and *Family Britain 1951–1957* (2008).

180 *Guardian*, 15 October 2011; *Observer*, 16 October 2011.

181 Isaacs, *Look Me in the Eye*, pp. 372–96; Taylor Downing, 'History on Television', pp. 325–32.

182 Ted Turner would be another with the *Cold War* series. This project had the personal backing of Ted Turner who ensured that it would get made when many of his programming people were sceptical.

Bibliography

Arnold-Foster, Mark, *The World at War* (London: Collins, 1973), but see the edition with an Introduction by Richard Overy (London: Pimlico, 2001).

British Universities Film Council, *Film and the Historian* (London: BUFC, 1968).

Cannadine, David (ed.), *History and the Media* (Basingstoke: Palgrave Macmillan, 2004).

Chapman, James, 'Television and History: The World at War', *Historical Journal of Radio, Film and Television*, June 2011.

Cineaste vol. 9 no. 2, Winter 1978.

Collini, Stefan, *Absent Minds: Intellectuals in Britain* (Oxford: Oxford University Press, 2006).

Conlin, Jonathan, *Civilisation* (London: BFI, 2009).

Dillon, Robert, *History on British Television: Constructing Nation, Nationality and Collective Memory* (Manchester: Manchester University Press, 2010).

Downing, Taylor, 'The Great War: Television History Revisited', *History Today*, November 2002.

Downing, Taylor, 'Screen Saviours', *History Today*, August 2009.

Downing, Taylor, 'History on Television: The Making of *Cold War*', *Historical Journal of Film, Radio and Television*, August 1998.

Frankland, Noble, *History at War* (London: Giles de la Mare, 1998).

Haggith, Toby and Joanna Newman (eds), *Holocaust and the Moving Image: Representations in Film and Television since 1933* (London: Wallflower Press, 2005).

Holmes, Richard, *The World at War: The Landmark Oral History* (London: Ebury, 2007).

Houston, Penelope, 'Witnesses of War', *Sight and Sound* vol. 43 no. 2, Spring 1974.

Isaacs, Jeremy, *Look Me in the Eye: A Life in Television* (London: Little, Brown, 2006).

Journal of the Society of Film and Television Arts vol. 2 nos 9–10, 1974, given over to *The World at War*.

Lacey, Stephen, *Cathy Come Home* (London: BFI, 2011).

Leyda, Jay, *Films Beget Films: A Study of the Compilation Film* (New York: Hill & Wang, 1964).

Marwick, Arthur, *The Nature of History*, 3rd edn (London: Palgrave Macmillan, 1989).

McArthur, Colin, *Television and History: BFI Television Monograph* (London: BFI, 1978).

Morley, Peter, *A Life Rewound: Memoirs of a Freelance Producer and Director* (New Romney: Bank House Books, 2010).

Potter, Jeremy, *Independent Television in Britain Vol. 3 – Politics and Control 1968–80* (Basingstoke: Macmillan, 1989).

Potter, Jeremy, *Independent Television in Britain Vol. 4 – Companies and Programmes 1968–80* (Basingstoke: Macmillan, 1990).

Ramsden, J. A., 'The Great War: The Making of the Series', *Historical Journal of Film, Radio and Television* vol 22 no. 1, 2002.

172

Roads, Christopher, 'Film as Historical Evidence', *Journal of the Society of Archivists* vol. 3 no. 4, October 1966.

Rosenthal, Alan, 'The World at War: The Making of a Historical Documentary', *Cineaste* vol. 9 no. 2, winter 1978–9.

Sandbrook, Dominic, *State of Emergency – The Way We Were: Britain 1970–1974* (London: Penguin, 2010).

Sisman, Adam, *A. J. P. Taylor: A Biography* (London: Sinclair Stevenson, 1994).

Smith, Paul (ed.), *The Historian and Film* (Cambridge: Cambridge University Press, 1976).

Stearn, Tom, 'What's Wrong with Television History', *History Today*, December 2002.

Young, Michael and Peter Wilmott, *The Symmetrical Family: A Study of Work and Leisure in the London Region* (London: Routledge and Kegan Paul, 1973).

Credits

1. THE NEW GERMANY 1933–1939
Director Hugh Raggett
Writer Neal Ascherson
Film Editor Alan Afriat

2. DISTANT WAR September 1939–May 1940
Producer-Director David Elstein
Writer Laurence Thompson
Film Editor Peter Lee-Thompson

3. FRANCE FALLS May–June 1940
Written and Produced by Peter Batty
Film Editor Alan Afriat

4. ALONE May 1940–June 1941
Producer-Director David Elstein
Writer Laurence Thompson
Film Editor Jeff Harvey

5. BARBAROSSA June–December 1941
Written and Produced by Peter Batty
Film Editor Peter Lee-Thompson

6. BANZAI! Japan strikes 1941–1942
Written and Produced by Peter Batty
Film Editor David Taylor

7. ON OUR WAY – America enters the war 1939–1942
Written and Produced by Peter Batty
Film Editor Beryl Wilkins

8. DESERT – The war in North Africa 1940–1943
Written and Produced by Peter Batty
Film Editor Alan Afriat

9. STALINGRAD 1942–1943
Director Hugh Raggett
Writer Jerome Kuehl
Film Editor Beryl Wilkins

10. WOLFPACK 1939–1944
Producer-Director Ted Childs
Writer J. P. W. Mallalieu
Film Editor Beryl Wilkins

11. RED STAR The Soviet Union 1941–1943
Producer-Director Martin Smith
Writer Neal Ascherson
Film Editor Peter Beryl Wilkins

12. WHIRLWIND – Bombing Germany September 1939–April 1944
Producer-Director Ted Childs
Writer Charles Douglas Home
Film Editor Peter Lee-Thompson

13. TOUGH OLD GUT Italy November 1942–June 1944
Producer Ben Shephard
Writer David Wheeler
Film Editor Jeff Harvey

14. IT'S A LOVELY DAY TOMORROW Burma 1942–1944
Producer-Director John Pett
Writer John Williams
Film Editor Jeff Harvey

15. HOME FIRES Britain 1940–1944
Producer Phillip Whitehead
Writer Angus Calder
Film Editor Alan Afriat

16. INSIDE THE REICH Germany 1940–1944
Producer Phillip Whitehead
Writer Neal Ascherson
Film Editor Alan Afriat

17. MORNING June–August 1944
Producer-Director John Pett
Writer John Williams
Film Editor Jeff Harvey

18. OCCUPATION 1940–1943
Producer-Director Michael Darlow
Writer Charles Bloomberg
Film Editor Martin Smith

19. PINCERS August 1944–March 1945
Written and Produced by Peter Batty
Film Editor David Taylor

20. GENOCIDE 1933–1945
Producer-Director Mike Darlow
Writer Charles Bloomberg
Film Editor Peter Lee-Thompson

21. NEMESIS Germany February–May 1945
Producer-Director Martin Smith
Writer Stuart Hood
Film Editor Beryl Wilkins

22. JAPAN 1941–1945
Producer-Director Hugh Raggett
Writer Reginald Courtney Browne
Film Editor David Taylor

23. PACIFIC February 1942–July 1945
Producer-Director John Pett
Writer David Wheeler
Film Editor Jeff Harvey

174

24. THE BOMB
February–September 1945
Written and Produced by David Elstein
Film Editor Peter Lee-Thompson

25. RECKONING 1945 …
and after
Written and Produced by Jerome Kuehl
Film Editor Beryl Wilkins

26. REMEMBER
Written and Produced by Jeremy Isaacs
Film Editor Peter Jeff Harvey

Series Credits:

Research
Susan McConachy
Isobel Hinshelwood
Reginald Courtney Browne
Alan Patient
Ben Shephard
Film Research
John Rowe
Raye Farr
Michael Fox
Script Associate
Jerome Kuehl
Production Manager
Liz Sutherland
Supervising Film Editor
Alan Afriat
Assembly Editor
Jenny Holt
Dubbing Editors
Bob Harvey
Nola Schiff
Dubbing Mixers
Freddie Slade
Peter Rann
Gordon Temple
Laboratory Liaison
Roger Chinery

Graphics
John Stamp
Tony Bulley
Lester Halhed
John Affleck
Ian Kestle
Andy Newmark
Rostrum Camera
Peter Goodwin
Norman Hunt
Animation
Ray Moore
Film Cameramen
Mike Fash
Peter Lang
Sound Recordists
Keith Barber
Ron Ferris
Sandy MacRae
Basil Rootes
Production Team
Nigel Bell
Sean Fullerton
Rene Go
Andrew Hassam
Clive Hedges
Joanna Leck
Antonio Marques
David Marsh
Tony Message
Principal Archive Sources
Bundesarchiv – Koblenz
EMI Pathe
Movietone
National Archives – Washington
Nichiei – Tokyo
Novosti Press Agency – Moscow
Visnews
BBC Sound Archives
Cinesound Effects
Processing by
Humphries Laboratories
Music
Carl Davis

Narration
Laurence Olivier
Historical Adviser
Noble Frankland

Series produced in
Co-operation with the Imperial War Museum

Producer
Jeremy Isaacs

SPECIALS
SECRETARY TO HITLER
Producer Susan McConachy

WHO WON WORLD WAR TWO?
Producer Jerome Kuehl

WARRIOR
Executive Producer Jerome Kuehl
Film Editor and Producer Alan Afriat

HITLER'S GERMANY
1933–1939
Producer Raye Farr
Writer Jerome Kuehl

THE TWO DEATHS OF ADOLF HITLER
Producer-Director Martin Smith
Executive Producer Jerome Kuehl
Film Editor Alan Afriat

THE FINAL SOLUTION – 2 PARTS
Writer and Director Michael Darlow
Film Editor Peter Lee-Thompson

Specials narrated by Eric Porter

175

Index

Page numbers in **bold** indicate detailed analysis; those in *italics* denote illustrations; references to notes are indicated by the page number followed by 'n' + note number.

Also Published:

The Beiderbecke Affair
William Gallagher

Bleak House
Christine Geraghty

Buffy the Vampire Slayer
Anne Billson

Civilisation
Jonathan Conlin

Cracker
Mark Duguid

CSI: Crime Scene Investigation
Steven Cohan

Deadwood
Jason Jacobs

Doctor Who
Kim Newman

Edge of Darkness
John Caughie

Law and Order
Charlotte Brunsdon

The League of Gentlemen
Leon Hunt

The Likely Lads
Phil Wickham

The Office
Ben Walters

Our Friends in the North
Michael Eaton

Prime Suspect
Deborah Jermyn

Queer as Folk
Glyn Davis

Seinfeld
Nicholas Mirzoeff

Seven Up
Stella Bruzzi

The Singing Detective
Glen Creeber

Star Trek
Ina Rae Hark